# DUBLIN CITY

## THROUGH TIME

Ken Finlay

AMBERLEY PUBLISHING

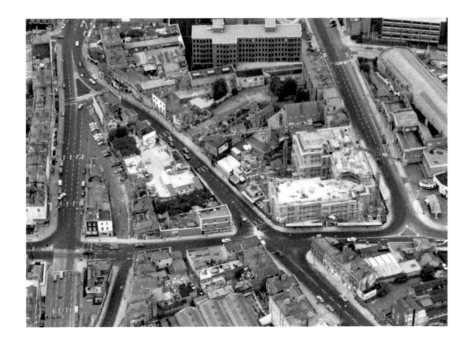

**Camden Street**
This photograph, taken in the late 1990s, shows from left to right: Lower Camden Street, Old Camden Street, Charlotte Street, and Harcourt Street. From the 1980s through to the late 1990s, Old Camden Street and Charlotte Street were extinguished to make way for the Camden Court Hotel, offices, apartments and retail outlets. The blue building in the foreground was the John Gleeson & Sons pub.

First published 2012

Amberley Publishing
The Hill, Stroud, Gloucestershire, GL5 4EP
www.amberley-books.com

Copyright © Ken Finlay, 2012

The right of Ken Finlay to be identified as the
Author of this work has been asserted in accordance with
the Copyrights, Designs and Patents Act 1988.

ISBN 978 1 4456 1271 3 (print)
ISBN 978 1 4456 1294 2 (ebook)

British Library Cataloguing in Publication Data.
A catalogue record for this book is available from the British Library.

Typesetting by Amberley Publishing.
Printed in Great Britain.

# Introduction

For me the centre of Dublin begins around Camden street. It may seem a strange place to start, but that was where I grew up and so every journey began from there. And it was there, too, that I saw at first hand how the city changes over time. Back in the late 1950s, families still lived on Camden Street; one by one they went. Later, in the 1980s, familiar streets were obliterated – Charlotte Street and Old Camden Street for example – but they had been allowed (encouraged would be more accurate) to fall into disrepair over the previous two decades.

And it was there that I had my first brush with the law (excepting the charges of horse-rustling which were never proved) when our 999-year lease ran out – it was legal, said the lawyers, but I still don't understand how a lease can date from before the arrival of the Normans. We faced being evicted from our home, but thanks to my solicitor sister, Margaret, the day was saved and my mother received enough money to safeguard her old age.

Today, there are people living on Camden Street again and the pace of change has slowed, just like it has around the city. The Celtic Tiger came and went, did a fair amount of damage to the city centre, and succeeded in part in turning once-distinctive streets into carbon copies of European models. O'Connell Street became, and still is, the playground of city planners who seem obsessed with computer modelling – square trees in O'Connell Street would be a prime example. Nelson's Pillar was replaced with 'the world's tallest sculpture' (sigh!) and the General Post Office now looks completely out of place in a modern wonderland.

I've tried to replicate as close as possible the views of the old postcards and photographs, but there were quite a few that were simply not possible. The reasons are varied but mostly come down to trees, traffic, shadows and signage.

Trees. As a city-dweller you tend to ignore trees; you've seen them so often they become invisible, but not when you are trying to take photographs (examples include the Four Courts and the Royal Barracks (National Museum)). And, believe me, there are a lot more trees in the city centre than there were in the early 1900s.

Traffic. As a youth I weaved my way through traffic with not a care in the world. Time, however, has caught up with me and I am no longer the sprinter I once was. As an example, I did not even attempt to replicate the old Westmoreland Street image as the traffic is relentless and unpredictable. Photographing Christ Church without traffic proved impossible!

Shadows. The human eye doesn't really see shadow. The brain processes the information and you don't give it a second thought – cameras are much less forgiving.

Signage. I lost count of the number of times I had to move around to prevent signage getting in the way. I won't be the last to say it – we need fewer signs around town.

Some parts of the city centre featured in many old postcards, others didn't – I have hundreds of old postcards of O'Connell Street but not one of Camden Street. As you get closer to town the gaps are fewer, and many of the sidestreets appeared on postcards. I used a few old photographs, but in the main the old images come from postcards.

There are some glaring omissions; there is a good argument for extending the area covered as far as the Royal Canal, but space and time were limited.

I haven't concentrated on detailing the history of Dublin, as it has been often told elsewhere, but if there is something you would like to know, or an old picture you might like taken today, just send me an email (kenfinlay@gmail.com) and I'll do my best to help.

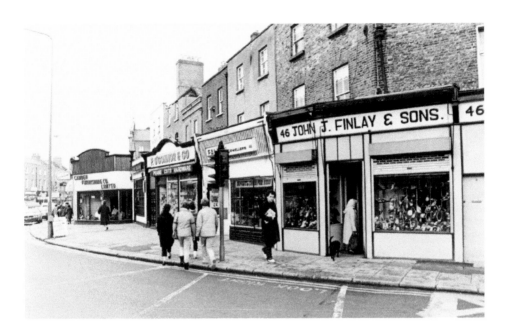

## Camden Street

To misquote Thomas Hood, 'I remember, I remember, the shop where I was born' – it was the Rotunda actually, but of that I have no memory. John J. Finlay & Sons, Boot and Shoe Merchant, was my family's shop and home until shortly before it was demolished in the late 1990s to make way for a new street, Charlotte Way. Both it and Fallons Jewellers next door shared the same address of 46 Lower Camden Street; our postal address was 46a. All of the shops in this section of Camden Street were added on to existing townhouses.

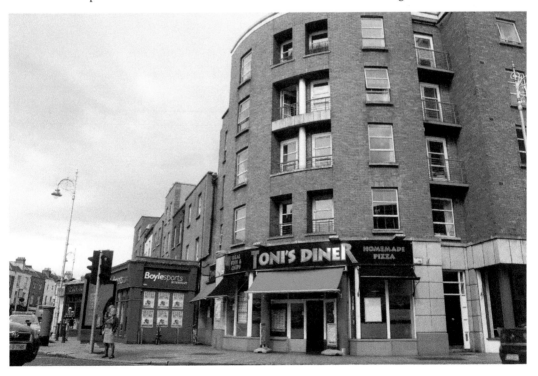

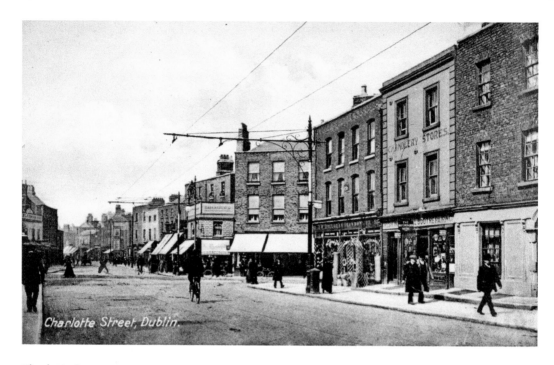

Charlotte Street, Dublin.

## Charlotte Street

Rather an odd postcard as, despite being described as Charlotte Street, it was taken in and shows Charlemont Street. The area beyond the crossing is Charlotte Street, now completely built over. In fact, nothing shown in the older photograph survives. The building behind the cyclist (Gallagher's Tobacconist) was a post office in the 1960s and '70s and, according to local lore, had been a hunting lodge long before the area was built up. The buildings on the right are T. W. Halloran, Ironmonger, and the Irish (illegible) Boot Repairing.

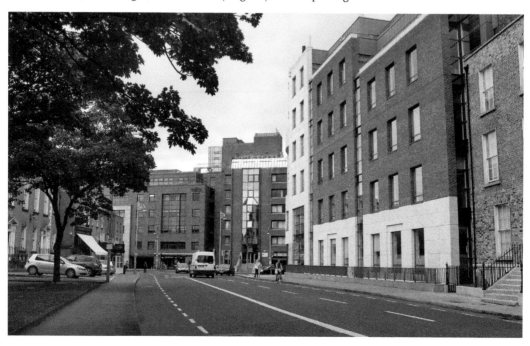

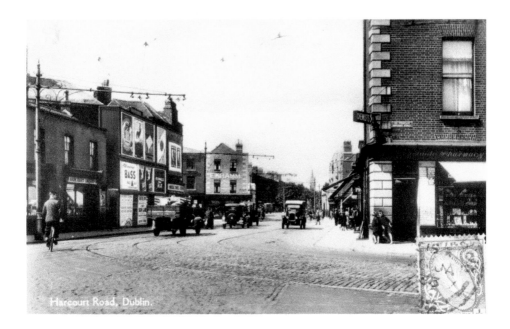

## Harcourt Road

Progress comes at a cost; Harcourt Road, leading to Charlemont and Charlotte Streets and on to Kelly's Corner, was once a bustling area – today it is a sterile office environment, enlivened only by the opportunity every couple of minutes to watch the LUAS take the corner slowly. And that amusement quickly wears off! Among the items of interest in the postcard are the Harcourt Dairy, advertisements for Bass and O'Connell's Ale, and the premises of E. Kramm.

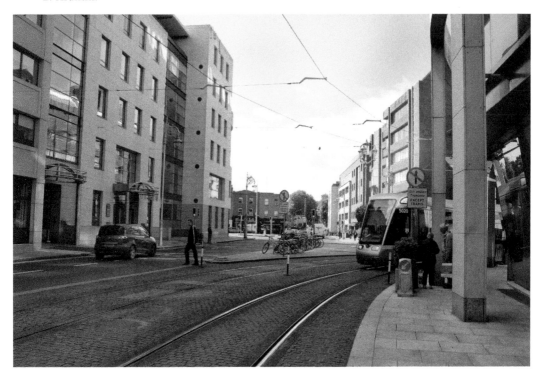

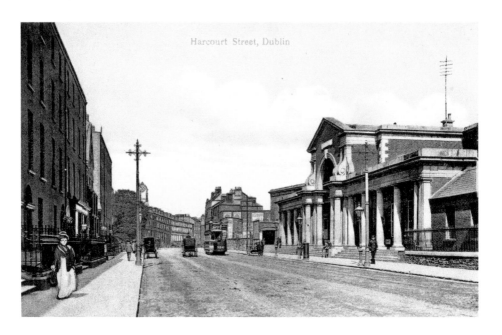

### Harcourt Street Station

Inside-out – trains once ran from inside; now the LUAS follows the same route but from outside the one-time station. The station was opened in 1859 as the terminus from Bray. The platforms, as with Pearse and Connolly stations, were above street level. One of the best-known photographs of the station shows a train hanging onto Harcourt Street after crashing through buffers on 14 February 1900. The last train ran on 31 December 1958. The area in the photograph now comprises entertainment/leisure venues.

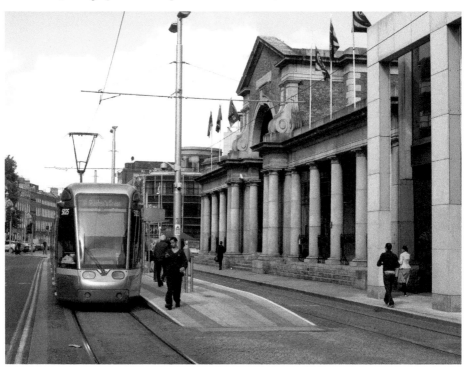

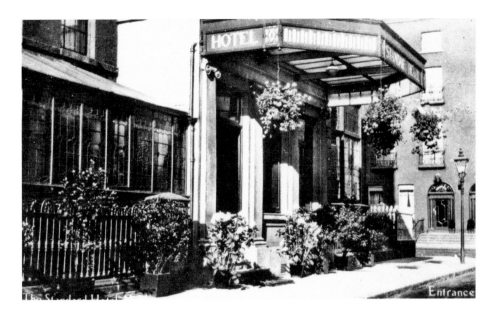

### Standard Hotel, Harcourt Street

Hotels are closing frequently these days as the recession and NAMA bites. But hotels have always had a shelf-life – the Burlington and Jury's both decamped from the city centre while the Russell and the Standard Hotels on Harcourt Street have completely disappeared. The Standard Hotel, Nos. 79–82 Harcourt Street, run by the Webb family, was used as an escape route by Michael Collins during a raid on No. 78 in November 1919 – he cracked a rib while getting through the skylight into the hotel. The hotel was on the list of Collins' murder squad on Bloody Sunday (21 November 1920) but the raid was called off. The photograph today shows the view from the old entrance – all that's there now is a blank, red-brick wall.

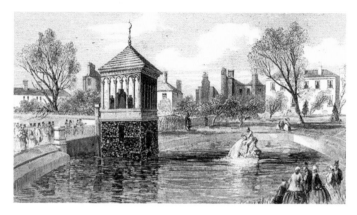

## Iveagh Gardens

Originally a private garden for John Scott, 1st Earl of Clonmell, they were redesigned in 1863 by Benjamin Guinness to back onto Iveagh House (now the Department of Foreign Affairs). It was on this site (including the National Concert Hall) that the Dublin Exhibition of 1865 was held. The gardens were private during my youth, which meant they were an ideal haunt while mitching from Synge Street Christian Brothers School – as we had to wear very identifiable school uniforms, the Iveagh Gardens offered the privacy, and the conkers, we craved. Today the Iveagh Gardens are open to all, with entrances at the NCH and from Clonmel Street (off Harcourt Street). It's much quieter than St Stephen's Green and still a great place to get away from it all.

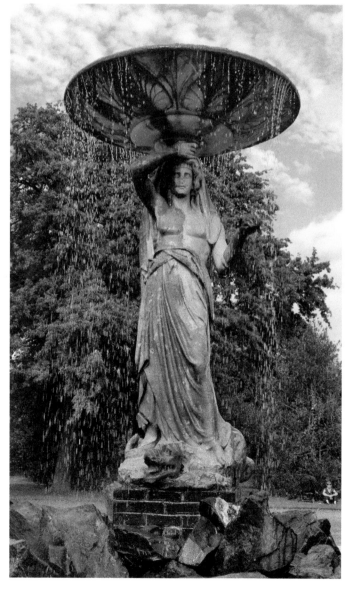

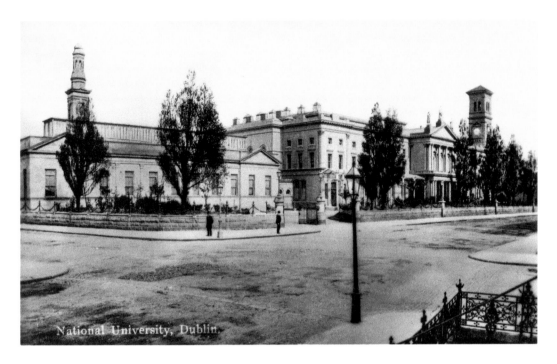

National University, Dublin.

### The National Concert Hall

The National Concert Hall, Earlsfort Terrace, sometime between 1908 and 1914. The Royal University of Ireland formally handed the building over to the newly created National University of Ireland – in reality University College Dublin. Work on rebuilding began in 1914. The tower on the far right was designed to hide the fact that it was actually a ventilation shaft – it contained bells and clock dials that had come from the General Post Office. It officially became the National Concert Hall on 2 September 1981, when it was opened by President Hillery.

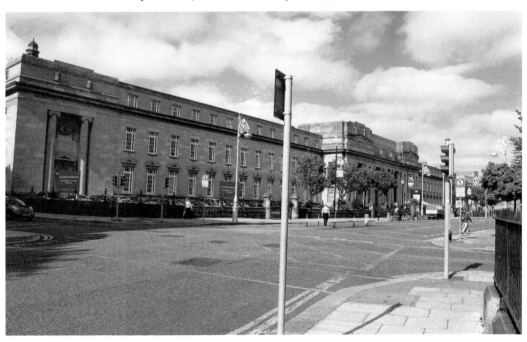

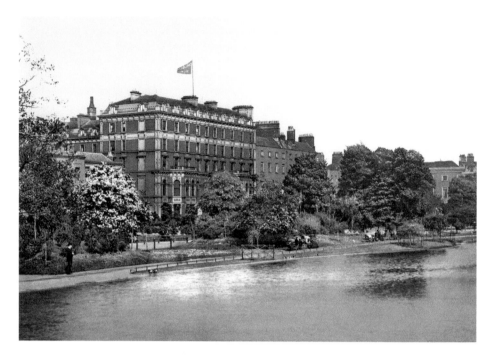

## Shelbourne Hotel

This hotel was founded by Martin Burke in 1824 and named after Dubliner William Petty Fitzmaurice, 2nd Earl of Shelburne, who (and it was news to me) was British Prime Minister (1782/83). During the 1916 Rising, the Shelbourne was garrisoned by British troops who fired down on Michael Mallin's troops in St Stephen's Green. If your eyesight is up to it you can still see the marks of return fire. In 1922, the Irish Constitution was drafted in room 112, now known as the Constitution Room.

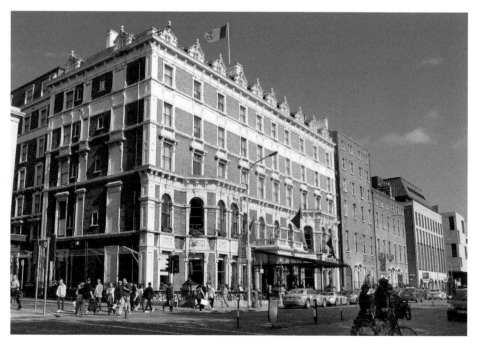

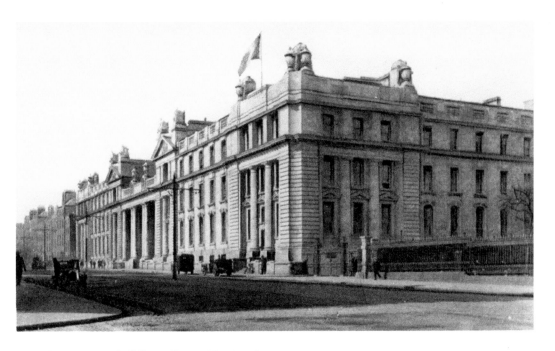

Government Buildings; Upper Merrion Street

Built to house the Department of Agriculture & Technical Instruction, the Local Government Board and the Royal College of Science, the buildings were finished in time to be occupied by the just-arrived Irish Free State government. The foundation stone had been laid as far back as 1904. Building originally started at the back of the complex and it was not until 1913 that eighteen four-storey houses at the front were demolished. Science students studied there from October 1911 until they were moved to Belfied in 1989. Today, the Government Buildings house the Department of Finance, Office of the Attorney General and the Department of the Taoiseach.

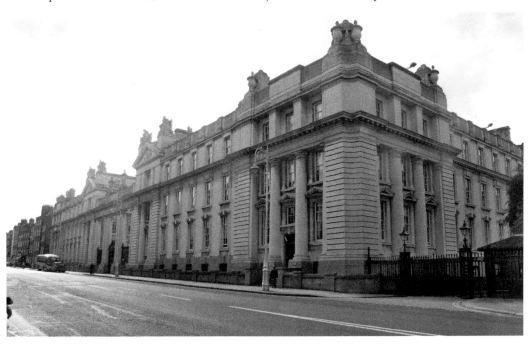

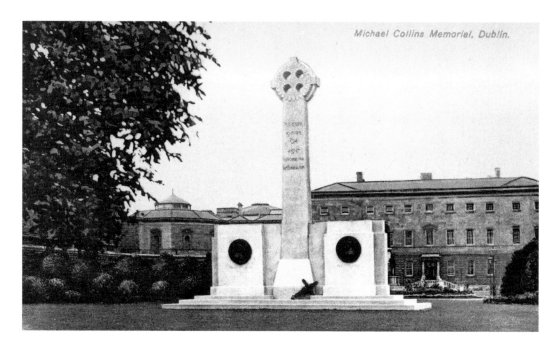

*Michael Collins Memorial, Dublin.*

### The Griffith-Collins Cenotaph, Leinster Lawn

The postcard can be dated between August 1923 and August 1927. The monument, marking the deaths of Michael Collins and Arthur Griffiths, was officially unveiled on 13 August 1923 by President Cosgrave. A central tablet (not included in the photo above) was added on 21 August 1927 to remember Kevin O'Higgins, who had been murdered in Booterstown a month earlier. The Cenotaph was, however a temporary structure, which had to be regularly painted to prevent mildew – even the tablets were temporary. It was not until 1950 that the Cenotaph was replaced with a permanent memorial – an obelisk.

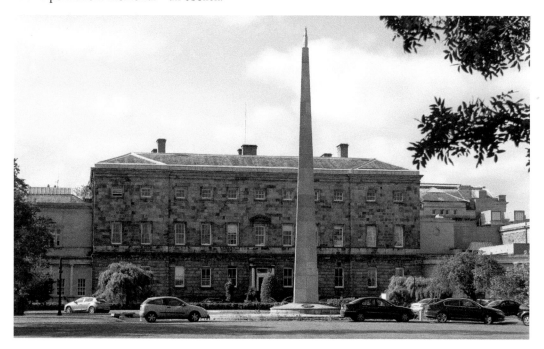

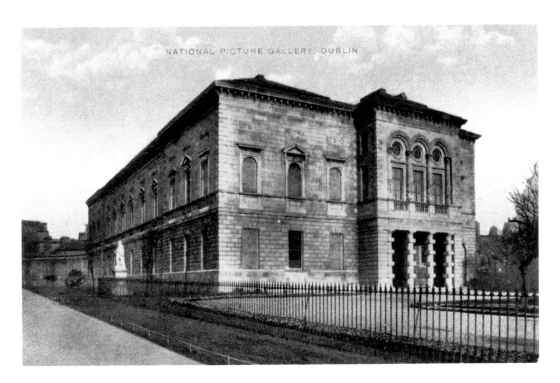

National Gallery of Ireland, Merrion Square

There's no question about which painting most impressed me as a child – *The Marriage of Strongbow and Aoife*, a 10-foot by 16.5-foot creation from Daniel Maclise. The nation recently decided that William Burton's *Hellelil and Hildebrand, The Meeting on the Turret Stairs*, was its favourite – a bit soppy for my tastes, but each to his own. You'll also find works by Jack B. Yeats, Carravagio, Rembrandt, Vermeer and Picasso. Admission is free.

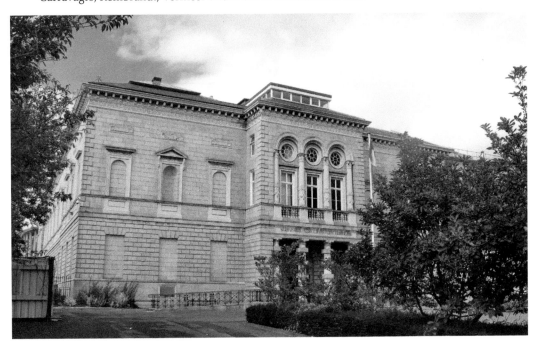

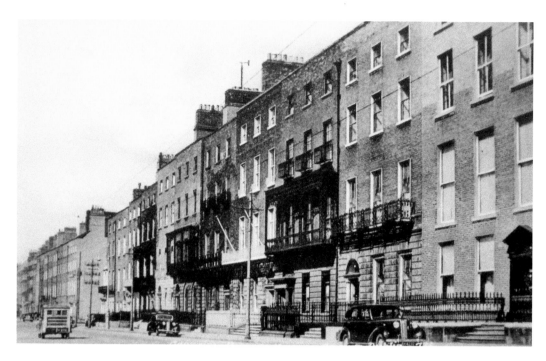

## Merrion Square, East Side

Building began in 1762 and the square was mostly completed by the end of that century. There are Georgian buildings on three sides, while the fourth has the National Gallery, Leinster House grounds and the Natural History Museum. Many houses have plaques concerning one-time residents, among them Daniel O'Connell, W. B. Yeats, Sheridan le Fanu and Oscar Wilde. Most of the houses are now used for office accommodation. Eagle-eyed readers may notice that the present-day photograph is taken from a different angle – an exact reproduction would have featured a very long line of tour buses.

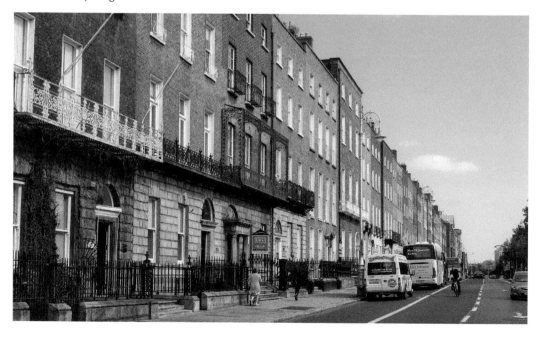

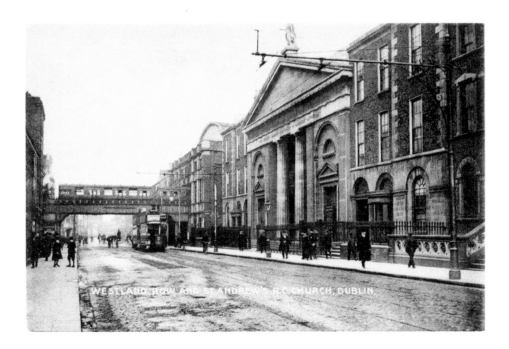

## Westland Row

The year 1776 is normally associated with the American Declaration of Independence. In Dublin, however, it marks the construction of what is now Westland Row. It was then called Westlands after a local property owner, William Westland. The area on the left of both photographs is now mainly comprised of Trinity College buildings. On the right are Pearse station, St Andrew's church, and the Royal Irish Academy of Music (RIAM) – I still have my Grade IV Piano certificate from the RIAM; my parents wisely gave up at that point.

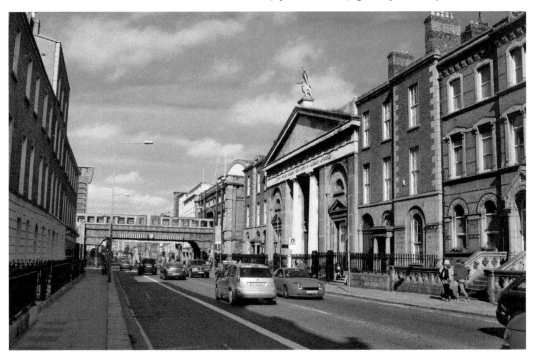

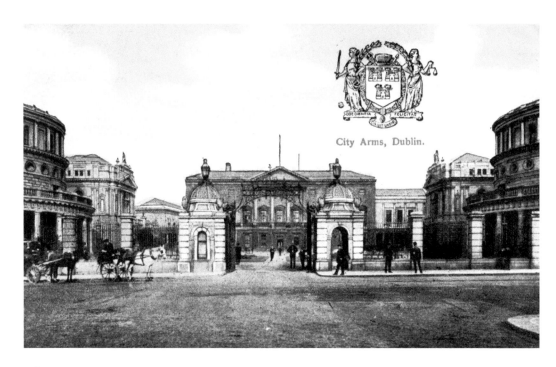

City Arms, Dublin.

## Leinster House

Originally home to the Dukes of Leinster, it came into the hands of the Royal Dublin Society (RDS) in 1815. The RDS added two wings to house: the National Library of Ireland and the National Museum of Ireland. The Dublin Horse Show and the Dublin Spring Show were held in the garden of Leinster House until the premises were taken over by the Irish Free State in 1924. It has housed the Dáil and Seanad ever since.

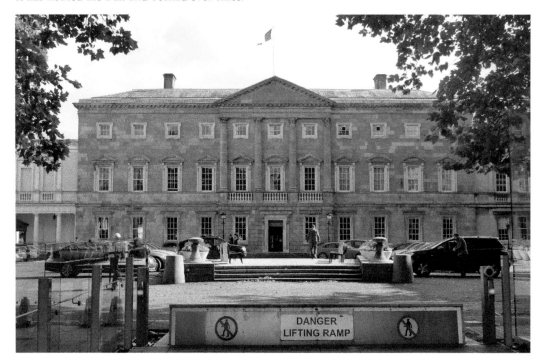

DANGER
LIFTING RAMP

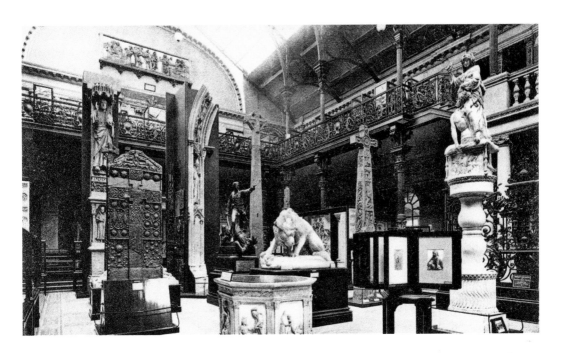

## National Museum

The postcard from which the older photograph comes was posted in 1903 and nothing much had changed by the time I was first introduced to the Museum in the mid-1960s. There was stuff everywhere – stuff piled on top of stuff – and it was an absolute joy to potter around. I particularly remember the shrunken heads, and the magnificent collection in the armoury (closed now for health and safety reasons apparently). Today the clutter has gone and with that, for me at least, some of the charm.

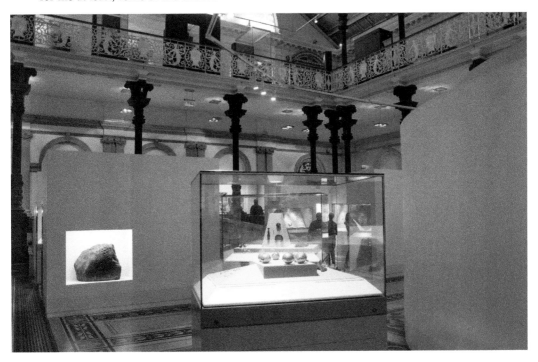

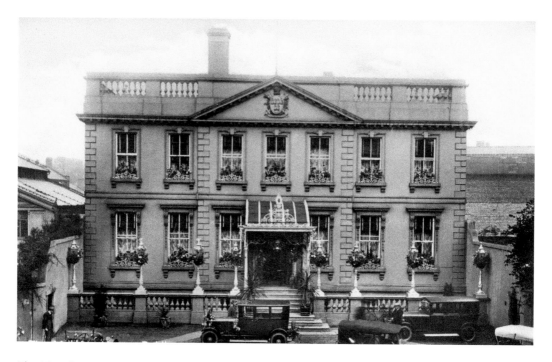

### The Mansion House, Dawson Street

It is generally reckoned to be the best address in Dublin, although personally I would prefer the Provost's House at the corner of Grafton Street. Built in 1710 by Joshua Dawson, the Mansion House has been the official residence of the Lord Mayor since 1715. The partially visible building on the right is the 'Round Room' where the First Dáil met in 1919 to reaffirm Irish Independence from Britain – in 1969 a 50th-anniversary joint-session of the Dáil and Seanad was held there. The distinctive portico of the Mansion House was erected to mark the visit of Queen Victoria in 1900.

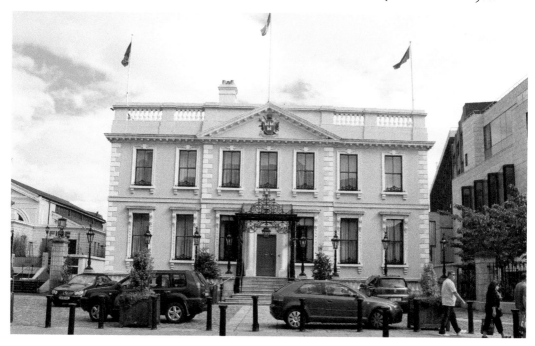

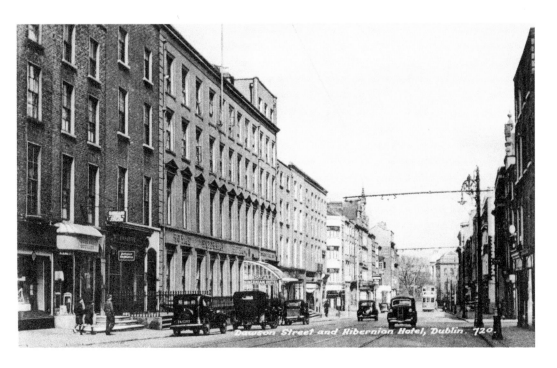

Dawson Street and Hibernian Hotel, Dublin. 720.

### Dawson Street

It's named after the Dawson family, who built many of the surrounding streets and the Mansion House. The building in the older photograph is the Royal Hibernian Hotel, which was demolished in 1984 to make way for an unremarkable retail and office development. The street today is an odd mixture of old and new buildings, shops, offices, restaurants and bars – including, close to the Stephen's Green end, the smallest pub in Dublin, the Dawson Lounge – it's my pub of choice once a year after bringing my nephews to the 'panto' in the Gaiety.

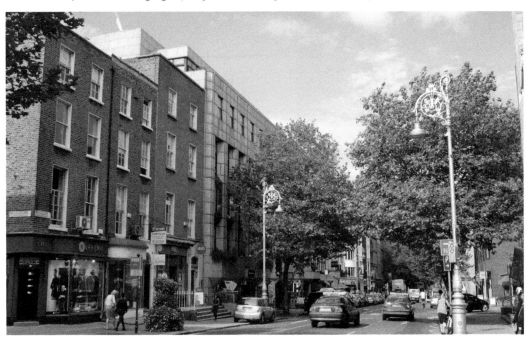

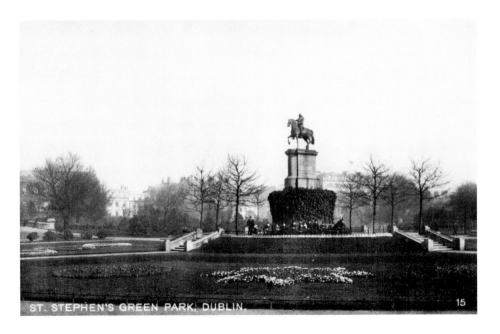

ST. STEPHEN'S GREEN PARK, DUBLIN.    15

### King George, St Stephen's Green

This bronze equestrian statue of King George II stood in the centre of Stephen's Green from 1758 until it was blown up in 1937 – the day after the Coronation of his namesake, George VI. Of all the royal statues that once dotted the Dublin landscape, the only one that remains is that of Prince Albert – discreetly hidden away in the grounds of Leinster House (backing onto the National History Museum, Merrion Street).

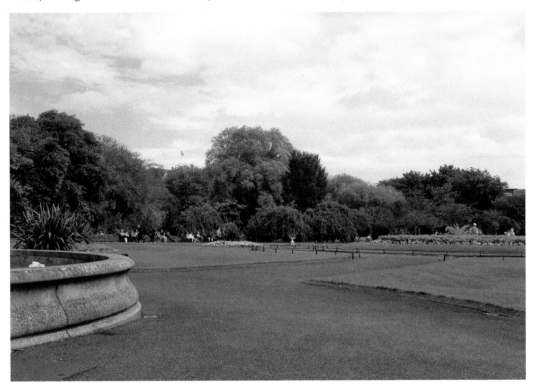

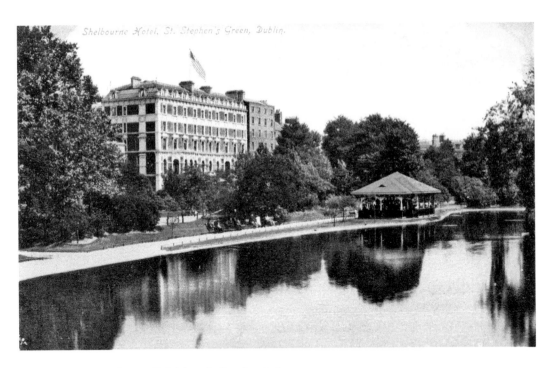

## View From O'Connell Bridge, St Stephen's Green

The lesser known of the two O'Connell Bridges in Dublin – it spans the artificial lake in St Stephen's Green. It is bounded by the waterfall at one end and the Kiosk (I always thought it was some kind of remodelled bandstand) at the other. The sole bandstand can be found over on the Iveagh House side. The lake takes its water from the Grand Canal at Portobello. The Shelbourne Hotel is clearly visible in the older photograph, but tree growth has made it invisible today.

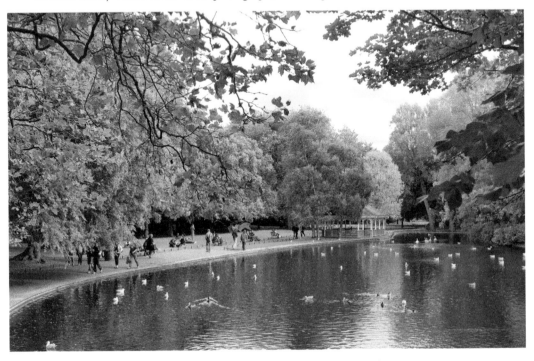

23

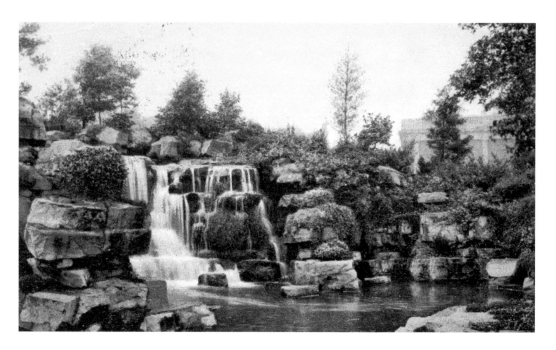

### St Stephen's Green Waterfall

When mitching from Synge Street Primary School it was best to stay out of plain sight and the fenced off area in St Stephen's Green certainly fitted the bill. The waterfall at the west end of the lake was perfect: two people could squeeze in behind the water and watch the world go by. Today it isn't working and hasn't been maintained. The stonework, by the way, isn't natural – it's Pulhamite; artificial rock that could be crafted to look however you wanted it.

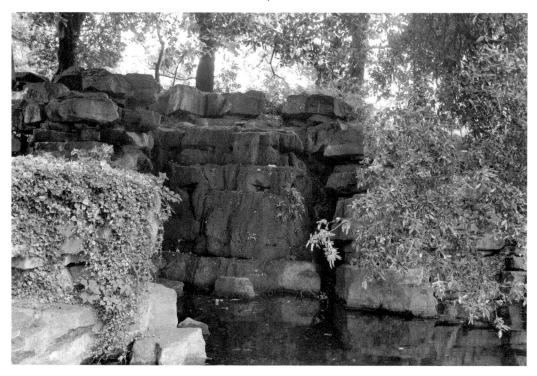

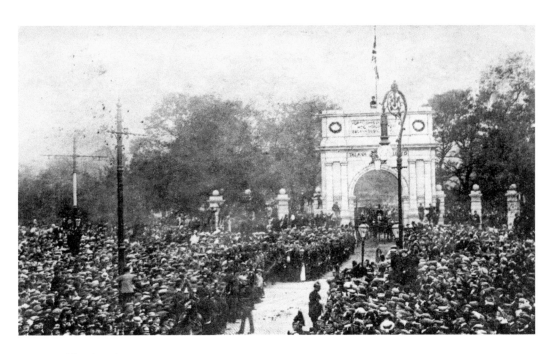

### Fusiliers' Arch

During the Boer War (1899–1902), four battalions (two regular and two militia) of the Royal Dublin Fusiliers took part in many major engagements – Ladysmith, Hart's Hill, Talana, Colenso, Tugela Heights – and had heavy losses. Fusiliers' Arch was designed by John Howard Pentland and erected by Henry Lavery & Sons. Funded by public subscription, it was officially opened, as pictured above, by the Duke of Connaught on 19 August 1907. It is said to be modelled on the Arch of Titus in Rome and the two do bear remarkable similarities.

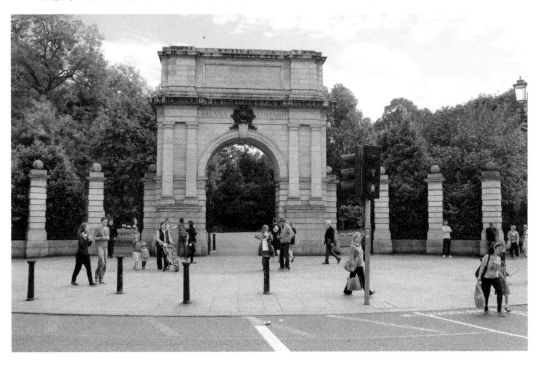

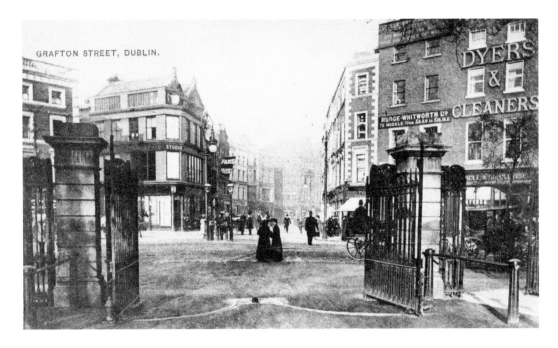

GRAFTON STREET, DUBLIN.

## Fusiliers' Arch

The older photograph predates the building of Fusiliers' Arch and allows a clear view down Grafton Street. The underside of Fusiliers' Arch bears the names of 212 fusiliers who died during the Boer War, though it has long been Dublin legend that at least one of those names (which one is never revealed) is that of a soldier who, having been separated from his regiment, decided to desert and walked home! The Dublin Fusiliers lost 4,700 men during the First World War – three Victoria Crosses were awarded, as were forty-eight Battle Honours and five Theatre Honours. The regiment was disbanded in 1922 upon the foundation of the Irish Free State.

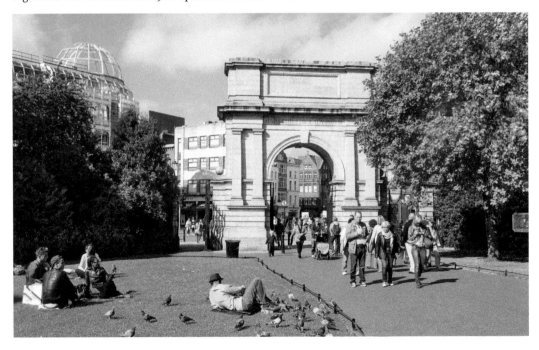

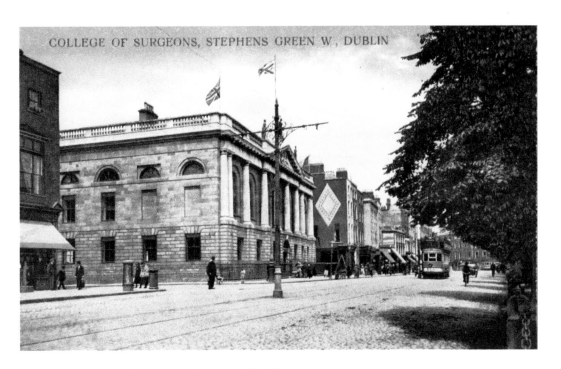

COLLEGE OF SURGEONS, STEPHENS GREEN W., DUBLIN

### Royal College of Surgeons in Ireland (RCSI)

The RCSI (formed in 1784) has been based at Stephen's Green since 1810 – prior to that the site was a Quaker cemetery. The foundation stone was laid by the Duke of Bedford on St Patrick's Day in 1806 and it was completed in March 1810. The LUAS Green Line from Stephen's Green opened on 30 June 2004 – trams had ceased operating in central Dublin in the 1940s. St Kevin's Bus Service, for many years Dublin's sole private bus company, operated from this side of Stephen's Green until the stop was moved to Dawson Street to facilitate the LUAS.

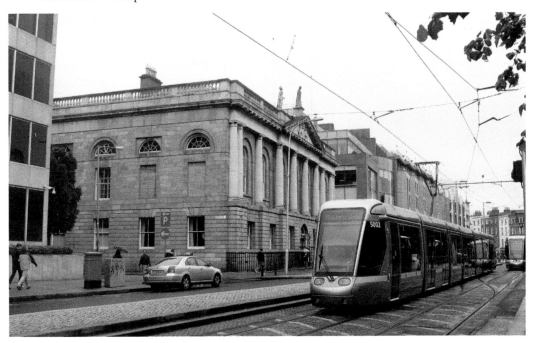

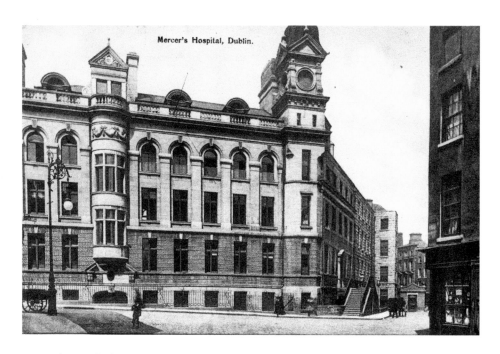

Mercer's Hospital, Dublin.

### Mercer's Hospital

Mary Mercer opened a house for poor girls in 1734. When she died a decade later, she left money to found a hospital there for the sick and poor – it became Mercer's Hospital. While her money built the hospital, it did not provide for running costs. Fundraising events were regular – among them the first performance of Handel's *Messiah* (Fishamble Street, 13 April 1742). In the 1980s, government policy saw the closure/merger of many city-centre hospitals – Mercer's Hospital closed in 1983. There is still a medical link as it was taken over by the Royal College of Surgeons in Ireland (RCSI).

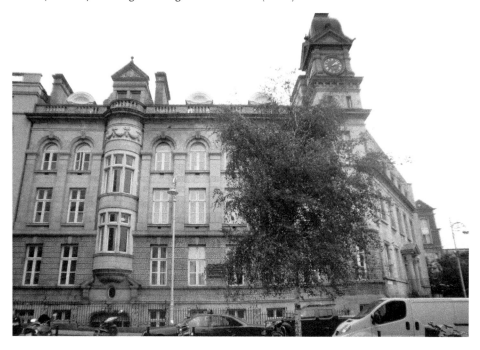

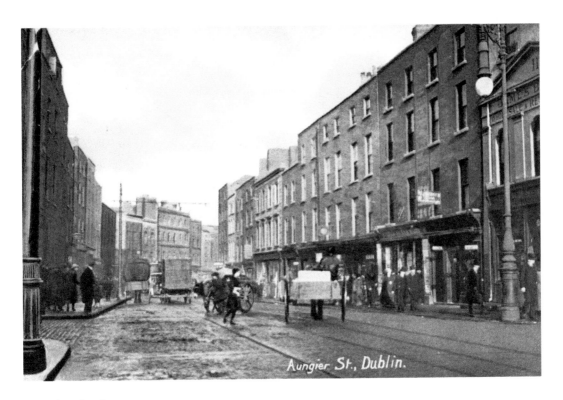

## Aungier Street

This street first turns up on Speed's 1610 map; at the time it was called St Stephen's Street. It was renamed after Sir Francis Aungier (1558–1632), Master of the Rolls. The street is best known as the birthplace (No. 12) of Thomas Moore (1779–1852), poet and composer, and author of *The Last Rose of Summer* and *The Minstrel Boy*.

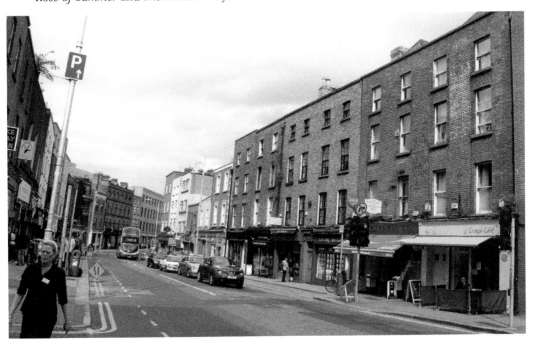

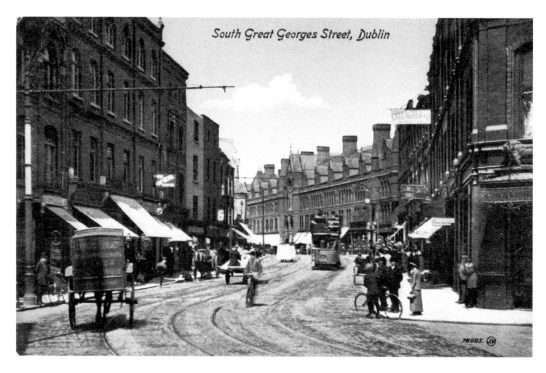

South Great George's Street, Dublin

## South Great George's Street

One of the traditional routes into the city, it can be found on Speed's map (1610), though most of what you see today dates from work in the rebuilding (1890–1930). Up to the late 1960s it was home to one of the great department stores, Pim Brothers. It was a toss-up whether their Santa was better than Switzers'. The other great store here was Dockrell's, which stretched from Jaipur to the end of the white canopy – it is now subdivided into many units.

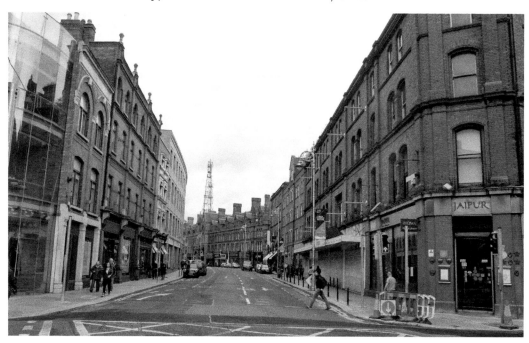

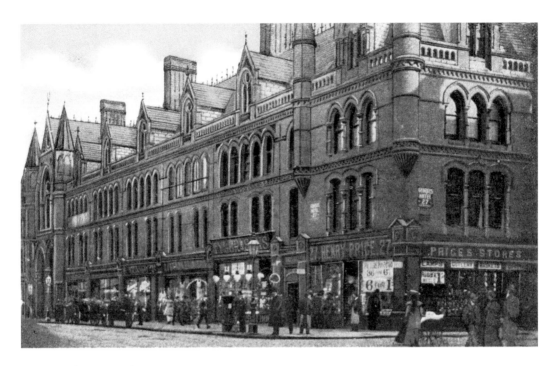

## South City Markets

While Grafton Street is the premier shopping street in south-central Dublin, South Great George's Street is also popular. Central to the street is the South City Markets, opened in 1881, seriously damaged by fire eleven years later and rebuilt. While the exterior has many of the shops you would expect, the covered interior is a real mixum-gatherum of shops and semi-permanent stalls selling an eclectic mix of just about everything. It's about as close as you'll get today to the hucksters' shop, which once proliferated in the back streets of Dublin.

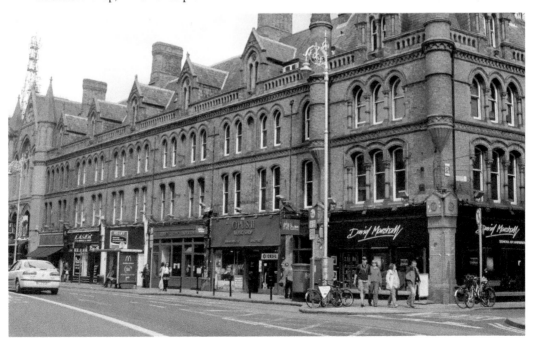

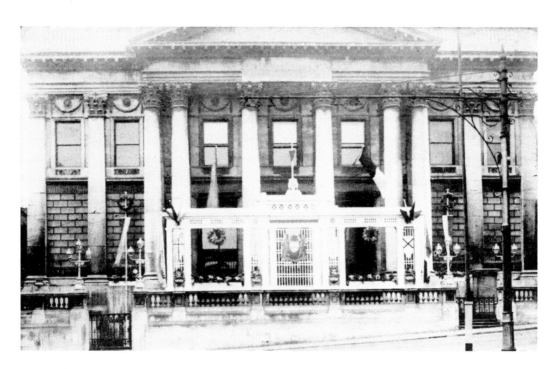

## City Hall

Dublin Corporation has been around for a long time, but it was not until 1852 that it moved (from the City Assembly House, South William Street, the Tholsel, Thomas Street, Skinner's Row – now Christchurch Place, and before that in the Thingmote, Suffolk Street) to its present location, the former Royal Exchange. It had been built as a meeting place for merchants – the old Custom House, which stood where the Clarence Hotel is today. In the older photograph, City Hall has been decorated the 1932 Eucharistic Congress.

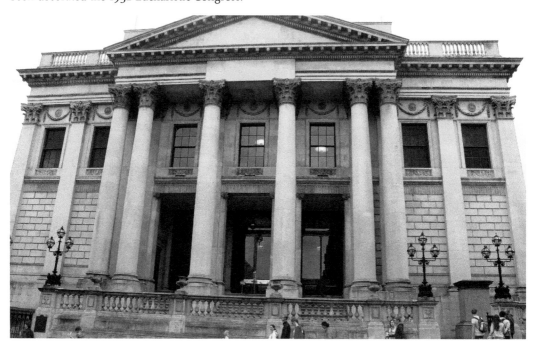

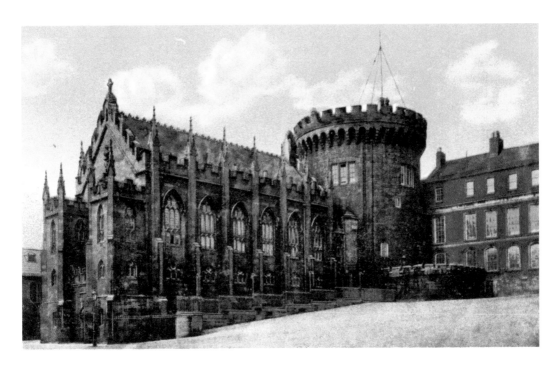

Chapel Royal, Dublin Castle

Properly known as the church of the Most Holy Trinity, it is built on the site of an earlier church and was opened in 1814. Designed in Gothic style by Francis Johnson, it is an extravagant building both inside and out. The coats of arms of all the British viceroys from 1172 (Hugh de Lacy) to 1922 (Lord Fitzalan) can be seen on display in carvings and stained glass windows. Outside there are carved heads of famous former notables – Brian Boru, St Patrick and Dean Swift among many others. Admission is free and it is definitely worth a visit.

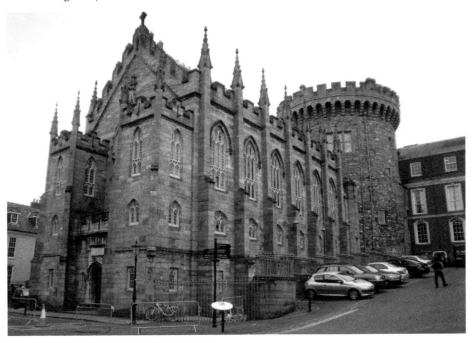

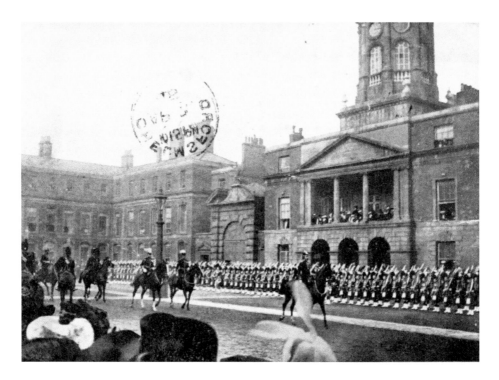

Bedford Tower, Dublin Castle

The top photograph shows the Trooping of the Colour in the Upper Castle Yard on St Patrick's Day, 1905. Such pomp and pageantry is rare these days, but Dublin Castle continues to be used for important occasions. Mostly it is a tourist attraction. The main building shown is the Bedford Tower (1760) – it was from here that the 'Irish Crown Jewels' (the Chains of Office of the Knight of St Patrick) were stolen in 1907, never to be seen again.

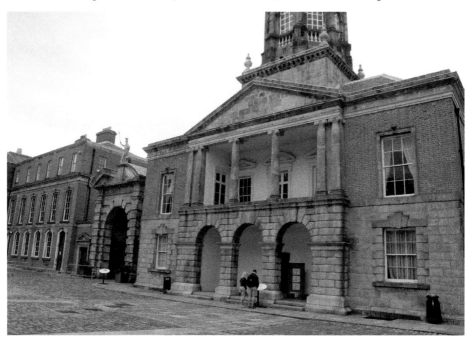

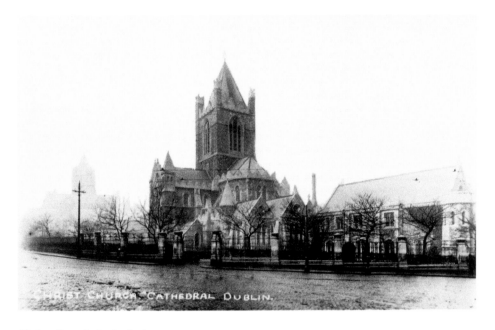

### Christ Church Cathedral

There has been a cathedral here since 1038; come the Reformation (1540) it was changed from a Catholic to a Protestant one. Anything that was worth a few bob was packed off to London to be melted down, while purely religious/worthless items were destroyed. Some of the more important reminders of the previous religion were burnt in front of the cathedral, including the Bacall Íosa (Staff of Christ) which, according to legend, had been given to St Patrick by Jesus before he came to Ireland. The cathedral was largely rebuilt between 1871 and '78.

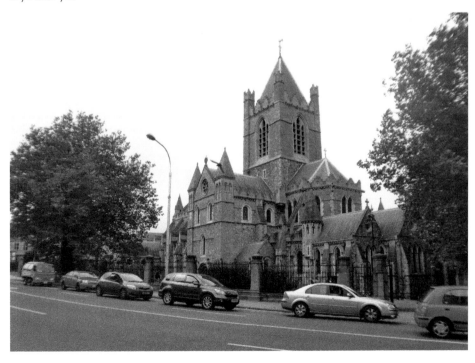

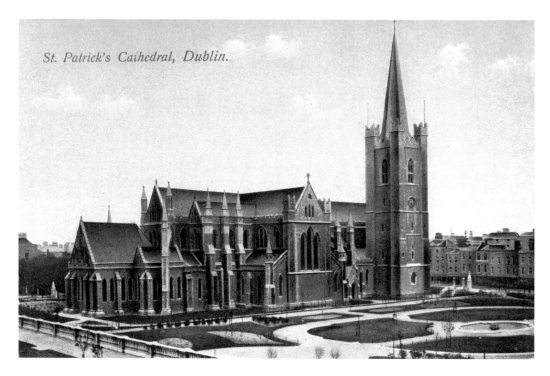

*St. Patrick's Cathedral, Dublin.*

### St Patrick's Cathedral

It is unusual for a city to have two cathedrals of the same faith – St Patrick's, the largest church in Ireland, is the National Cathedral of Ireland while Christ Church is designated as the Cathedral of Dublin and Glendalough. Both are Church of Ireland – in the case of St Patrick's, since 1537. The first references to a church on this site describe it as being on an island between two branches of the River Poddle – long since culverted, but a constant cause of dampness and flooding in the cathedral in the past (both Dean Swift's and Stella's graves were moved to their present locations because of this).

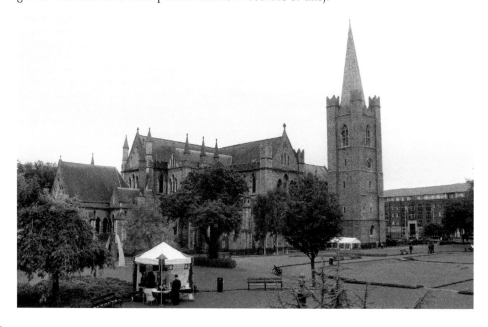

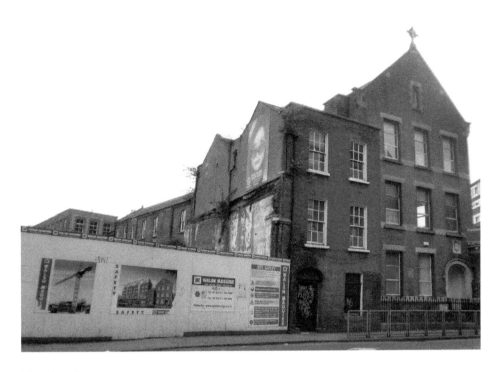

## The Coombe

While every other set of photographs in this book shows the past and the present, this shows the present (top) and what may yet be (below). 'Cathedral View' was due to be built by Walsh Maguire but the economic collapse saw that company placed into liquidation. While it is certainly possible that the 'Cathedral View' may be built, it is equally likely that, as on many other sites around the city, the end result may bear no resemblance to the current proposed building. And, despite the name, the view of St Patrick's Cathedral is, at least on the lower levels, very, very limited! The old building is the Holy Faith Convent, or Unholy Fate according to students.

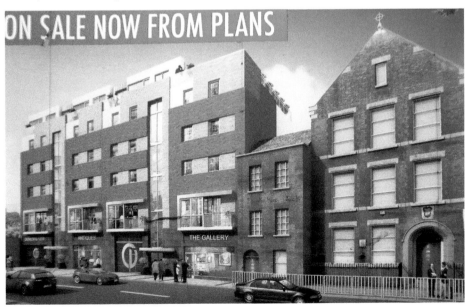

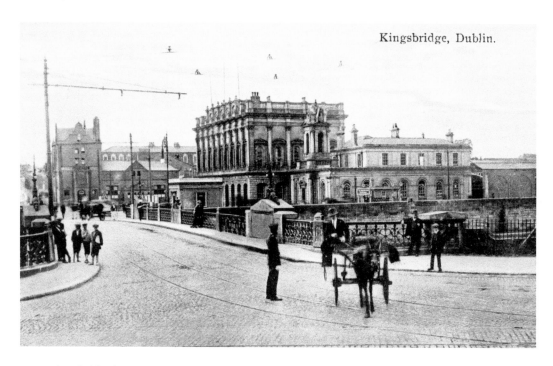

Kingsbridge, Dublin.

### Kingsbridge/Heuston Station

Originally Kingsbridge station (1846), it was renamed in 1966 in memory of Sean Heuston (1891–1916), who worked there as a clerk with the Great Southern & Western Railway Co., and who commanded the 1916 garrison in the nearby Mendicity Institute, Usher's Island. The buildings in the background in the old photograph were the nurses' homes for Dr Steevens' Hospital – they were demolished when the hospital closed in 1987. The former hospital is now an administrative centre for the Health Service Executive.

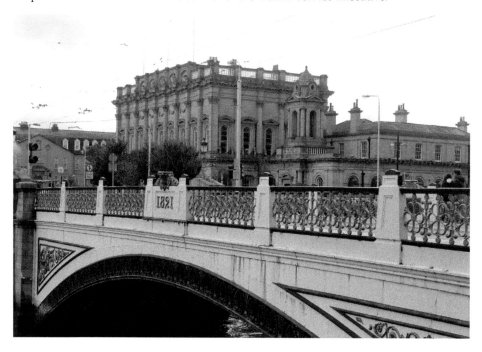

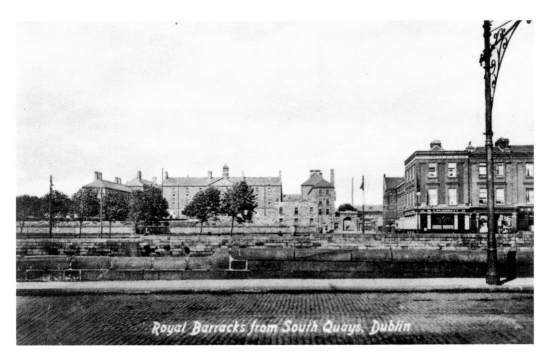

Royal Barracks from South Quays, Dublin

## Collins Barracks

Erected in 1701 and originally known as the Barracks, it became the longest-occupied barracks in Europe. It was renamed Collins Barracks by General Richard Mulcahy, Free State Army, immediately after it was handed over in 1922 – Michael Collins had died four months earlier. Taken over in September 1997, it became part of the National Museum of Ireland (History and Decorative Art). A memorial garden at Croppies' Acre, in front of the barracks, marks the spot where some of the executed 1798 rebels were buried.

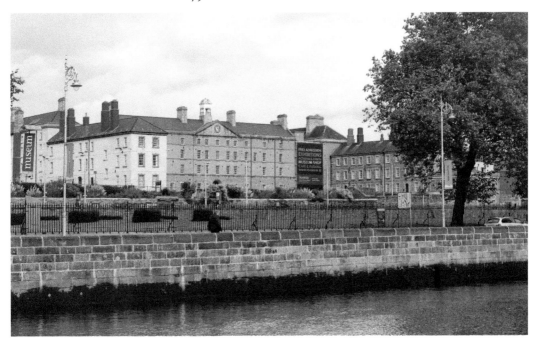

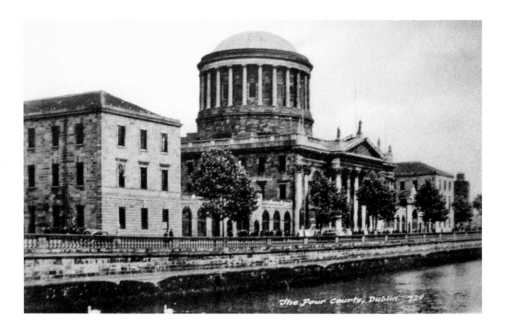

The Four Courts

Occupied by the legal profession since 1796 (building didn't finish until 1801), the name tells it like it really was, as it housed the courts of King's Bench, Exchequer, Common Pleas and Chancery. The Four Courts was destroyed at the start of the Civil War – whether it was by Irregular booby trapping or the accidental detonation of their munitions, which had been stored in the Public Records Office, is still debated. Free State shelling of the courts complex completed the destruction. Entirely restored by 1932, the exterior remains much the same, but the interior is completely different.

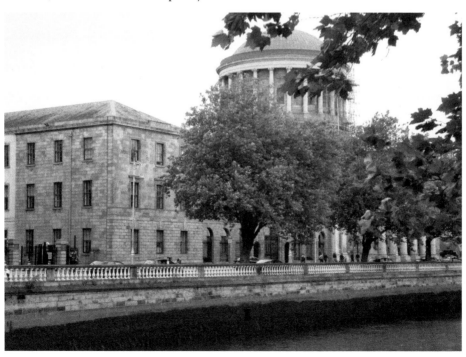

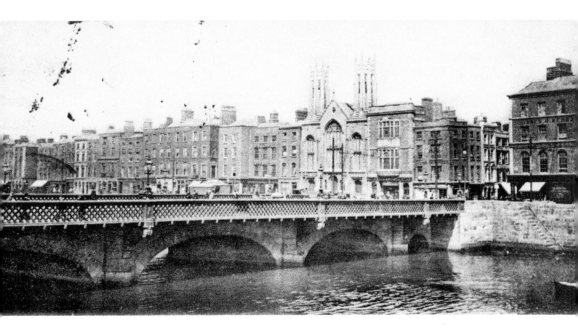

### Grattan Bridge

It's been called Grattan Bridge since 1874, but most people just call it Capel Street Bridge – some things just don't stick (like Aviva Stadium, with a bit of luck). It was originally built in 1676 to link various developments by Sir Humphrey Jervis. Between then and 1751 it partially collapsed on two occasions and was rebuilt (1753–55). It was rebuilt with London's Westminster Bridge as a model. In 2002, emergency repairs had to be undertaken when it was found that supporting stonework had been eroded. The church in the older photograph was the Presbyterian church, Ormond Quay.

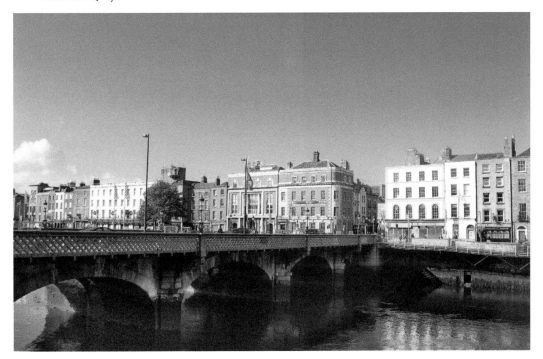

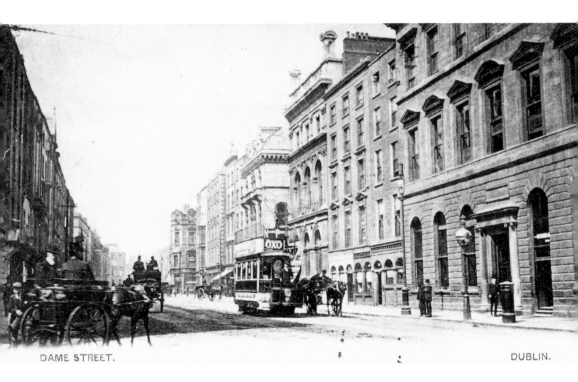

DAME STREET. DUBLIN.

## Dame Street

The nearest building on the right is the Commercial Buildings, but it isn't. When Sam Stephenson's monstrous Central Bank was being built (1975) the Commercial Buildings were to be dismantled and reassembled (at a 90-degree angle, so the doorway would face the bank plaza). What actually happened was that it was completely demolished and a replica built instead. The original doorway can still be seen on the Central Bank side. The Commercial Buildings were closely linked to one of Dublin's great mysteries – search online for the *Ouzel Galley* and you will not be disappointed. The Central Bank can be found to the right of the green post box in the modern photograph.

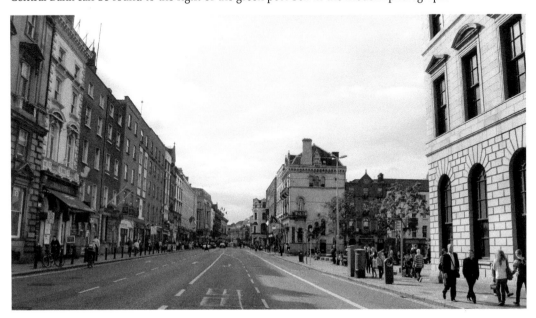

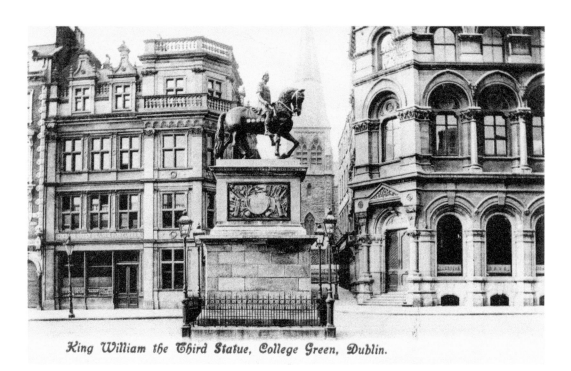

*King William the Third Statue, College Green, Dublin.*

### King William III, College Green

This equestrian statue of William of Orange was unveiled in 1701. Whenever passions were running high in the city it was a rallying point for some and a target for others. During Daniel O'Connell's 'Conciliation' period, any overt celebrations at the satue were actively discouraged. After independence it was largely ignored until it was badly damaged in a 1928 explosion and removed the following year.

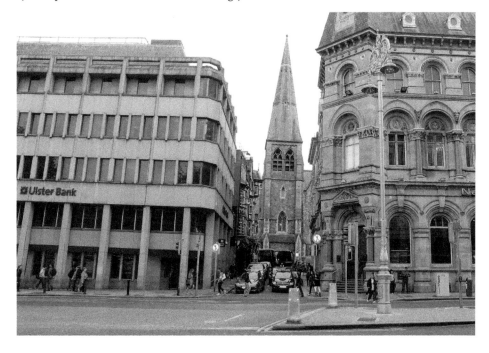

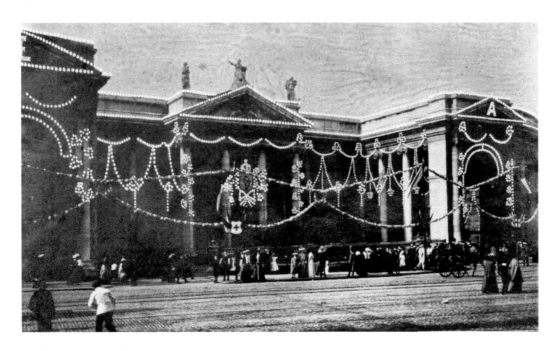

### Bank of Ireland, College Green

Count the number of windows on the old Houses of Parliament, now the flagship branch of Bank of Ireland ... not one. Revolting citizens were going to have their work cut out getting in. The foundation stone of the building was laid in 1729 and the Irish Parliament (Lords and Commons) sat there until 1 January 1801, when the Kingdom of Ireland ceased to exist. In recent years there have been calls for it to be handed over to the Irish people, calls that have been met with hollow laughter from the bankers. Admission to the old House of Lords is free. The older photograph shows decorations put up for the visit of Edward VII in 1903.

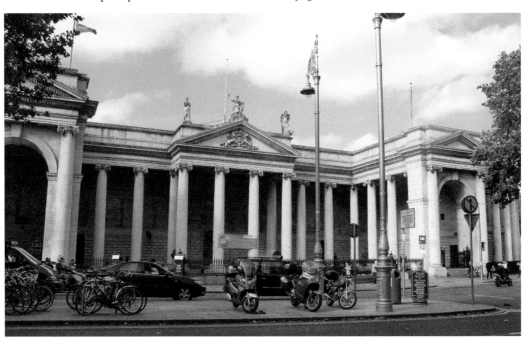

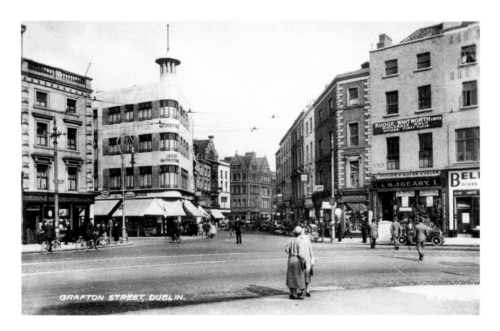

## Grafton Street (I)

Henry Street and Grafton Street vie for the title of Dublin's busiest shopping street, but Grafton Street usually feels busier. In 2008, just before the economic collapse, it was ranked in the world's top ten for commercial rental prices. My Galway granny was a big fan and whenever she visited we were guaranteed a visit to the Grafton Cinema to watch continuous cartoons, followed by a leisurely tour of Woolworths – beginning and ending at the sweet counter. The same woman never entered a bookies in her life but had no problem sending children in once their arms could reach up to counter-level. At Christmas we were brought to see Santa in Switzers, and brought back at night to see the window display – it just wasn't the same during the day. Oddly, perhaps, I don't think I ever entered Bewley's Café until I was well into my twenties – and I was not impressed (everyone has their own preferences!)

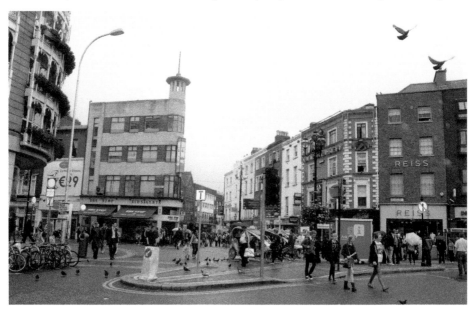

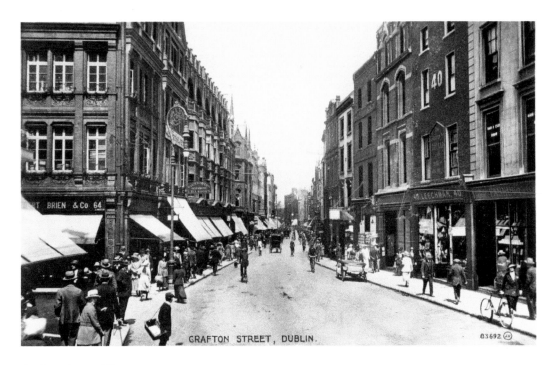

GRAFTON STREET, DUBLIN.

## Grafton Street (II)

A busy scene in yesteryear Grafton Street with signage for Leechman Bazaar, Fannin Ltd, Fallon Library and Woolworths. The mix of traffic is interesting, with horse-drawn carriages, bicycles and a single, sporty, car. Today the signage reflects the worst of the British High Street/American Mall retailing – Champion Sports, Burger King, Monsoon, HMV – it could be a busy street almost anywhere. The distinctive red paving is soon to be removed and replaced with grey granite.

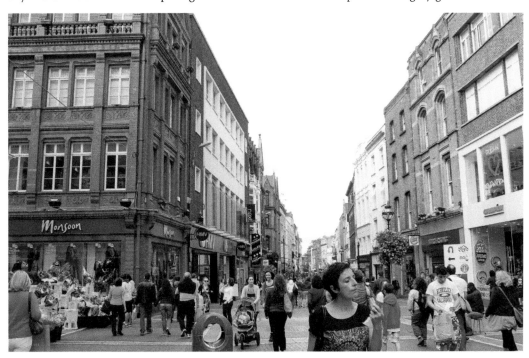

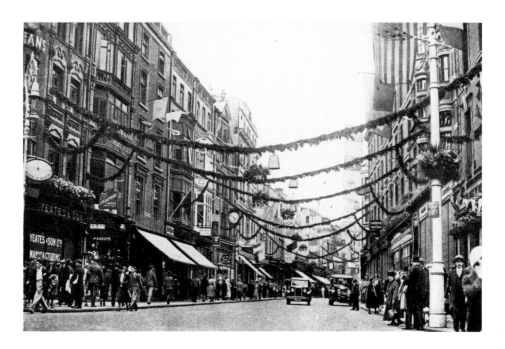

Eucharistic Congress, Grafton Street

The Eucharistic Congress held in Dublin in 2012 was but a pale shadow of the monster event of 1932 (and still by numbers alone the largest ever gathering held in the city). Back then the entire city was dressed out in its finest and Grafton Street was by no means the most elaborate. Among the legal curiosities for the 1932 Congress was that anyone could provide a taxi service for the duration, and all sales of alcoholic drink were banned between 2 p.m. and 6 p.m. on 26 June because of the Pontifical High Mass.

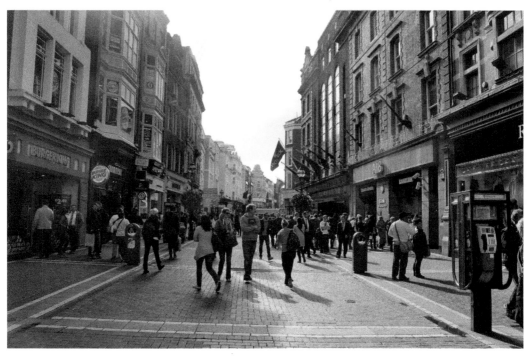

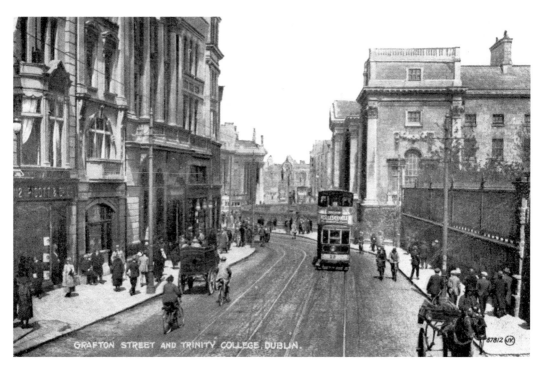

Grafton Street & Suffolk Street leading to Nassau Street

On 10 June 1904, Nora Barnacle met James Joyce in Nassau Street – a couple of days later she stood him up on their first date. If you are a tourist in Dublin and need information, my personal recommendation would be to start at the tourist office in Suffolk Street.

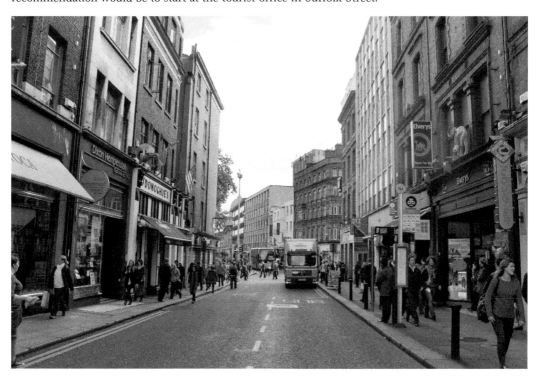

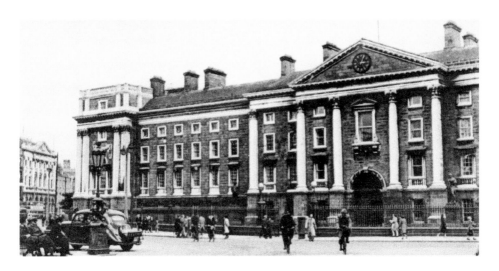

### Grafton Street – North End

It is hard to believe today that in the early 1700s it was a country lane – it was developed from 1708 as a residential street by the Dawson family. It wasn't until over a century later that the expanding city began to turn it into a shopping street. It's named, by the way, after an illegitimate son of Charles II – Henry FitzRoy, 1st Duke of Grafton. It surprises many people that the street between Nassau Street and College Green is, in fact, a little bit more of Grafton Street. There you can find Molly Malone's statue (she may not have been a real person – records are inconclusive – the famous song is a nineteenth-century music hall composition), and the Provost of Trinity's house behind a high wall. Today Grafton Street is fun to walk through – the street entertainment ranges from good to superb – but the mixture of shops is not great, more aimed at teenagers and tourists than your average Seán citizen (I can't speak for the female of the species). Grafton Street has been a pedestrian-only area since 1988 – but not this part!

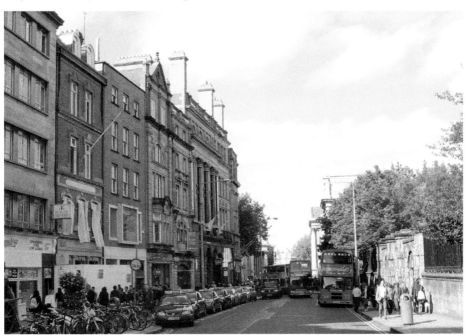

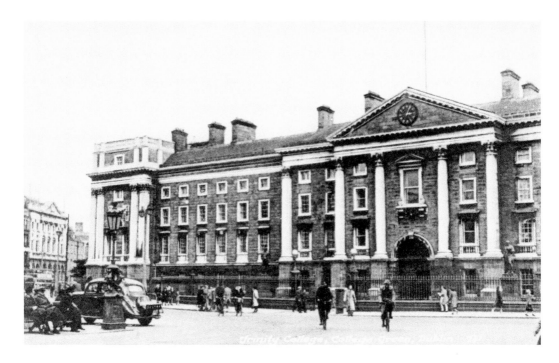

### Trinity College, Dublin

Queen Elizabeth granted the citizens of Dublin a charter in 1592 to incorporate Trinity College on the site of what had been All Hallows monastery. It was a Protestant university in a city ruled by Protestants – Catholics were allowed entry from the 1790s, though some posts were unavailable to them until 1873. From 1927 until 1970 the Catholic Church declared it a mortal sin for a Catholic to attend Trinity without the express permission of the archbishop – John Charles McQuaid for most of that time.

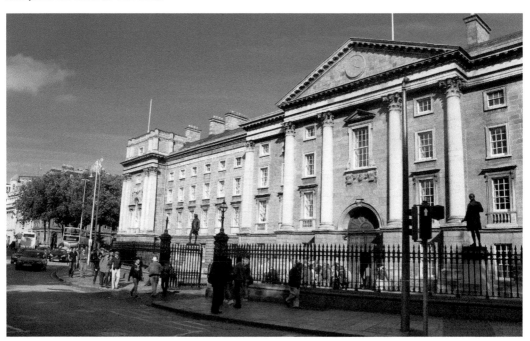

### Trinity College Campanile

Walking through the doors of Trinity and into Parliament Square, the first thing your eye is drawn to is the campanile (bell-tower). It was originally meant to be linked by a covered walkway to the buildings on either side. The four figures at the base of the belfry, sculpted by Thomas Kirk (1781–1845), represent divinity (seen holding a cross), science, medicine and law.

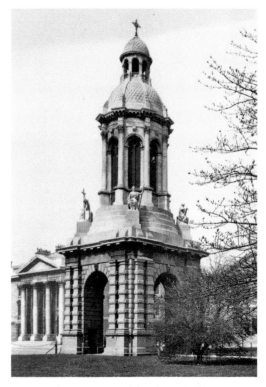

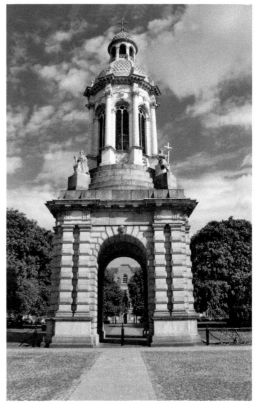

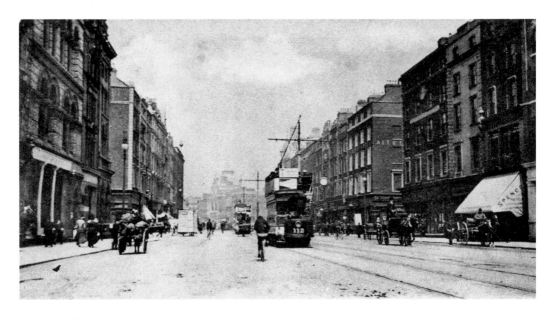

## Westmoreland Street

Named after John Fane, 10th Earl of Westmorland, Lord Lieutenent of Ireland (1789–94) – somewhere along the line an extra 'e' got added. In Herman Moll's 1714 map, Westmoreland Street is much narrower, at the very edge of the city and built up only on the Temple Bar (left) and Trinity College (behind) sides – the area to the right had yet to be reclaimed from the Liffey. The street as we know it today is a creation of the Wide Street Commission.

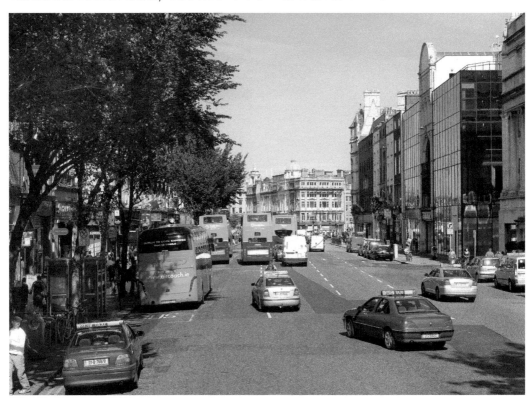

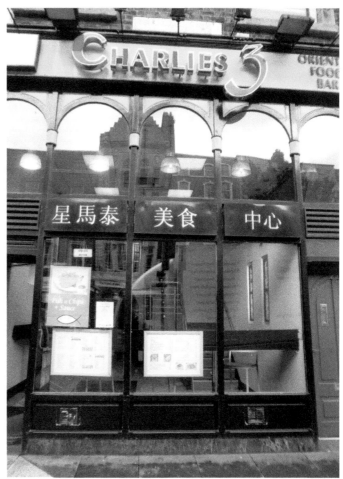

Harrison & Co.

'Hot mockturtle vapour and steam of newbaked jampuffs rolypoly poured out from Harrison's. The heavy noonreek tickled the top of Mr Bloom's gullet.' James Joyce was referring in *Ulysses* to Harrison & Co., Cooks and Confectioners, of 29 Westmoreland Street. Leopold Bloom might still find his tastebuds tickled with the cheap and cheerful Chinese food offered by Charlies 3. Then again, he might not. I have eaten there and I liked it; when it comes to food I am not difficult to please!

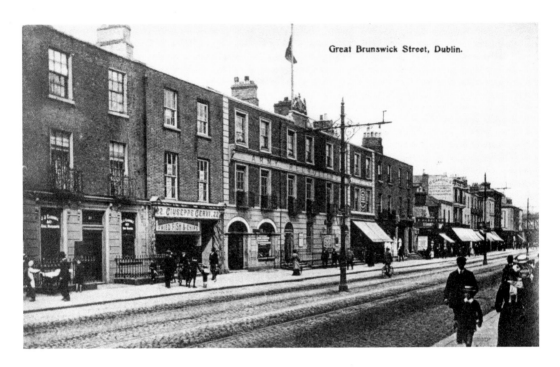

Great Brunswick Street, Dublin.

## Pearse Street

The first chipper in Dublin dates back, as far as anyone really knows, to the 1880s and the credit is usually given to Giuseppe Cervi and his wife, Palma. When Italian immigrant Giuseppe raised enough money from a handcart selling fish and chips, they set up shop at 22 Pearse Street (then Great Brunswick Street), just across the road from Trinity College. Today the premises are part of the Trinity Capital Hotel (just to the right of where the hedge ends). You can get chips at the hotel, but you can't get a 'one and one' – unless you count seabass or tiger prawns as chipper food!

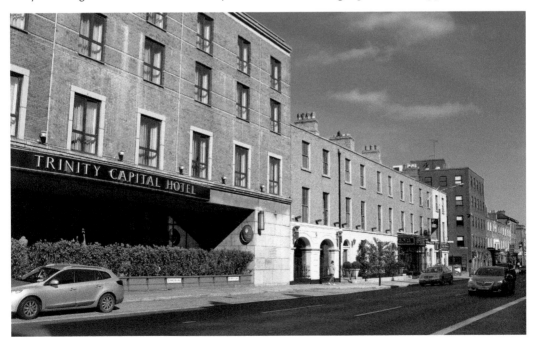

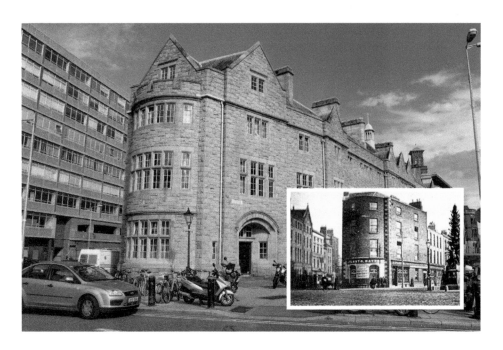

## Crampton Memorial, Pearse Street/College Street

Unveiled in April 1862, it commemorated Dubliner Sir Philip Crampton (1771–1858), one of the founders of Dublin Zoo, Army Surgeon General and discoverer of an ostrich eye muscle that was named after him! The sculptor, John Kirk, was proud of his work, though he appears to have been in a minority as it was locally known as the 'Pineapple'. It had three drinking fountains, two swans and a bust of the man himself. It was too delicate to last and was finally removed in 1959. There is a statue of the Long Stone there now, but the nearby Mr Screen is far more attractive.

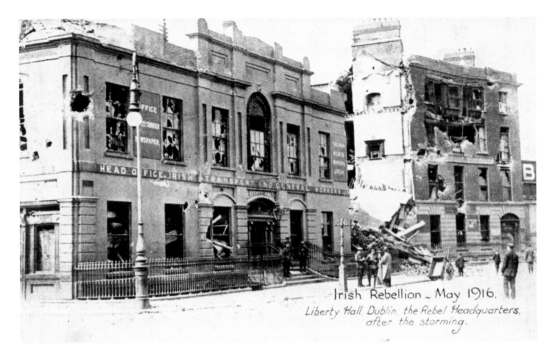

*Irish Rebellion – May 1916.*
*Liberty Hall, Dublin, the Rebel Headquarters,*
*after the storming.*

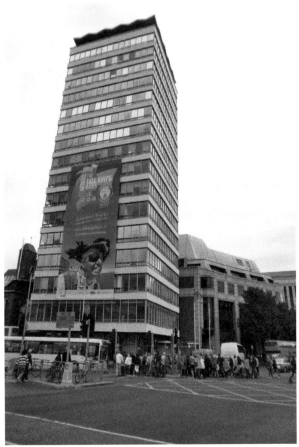

## Liberty Hall

Once the tallest building in Ireland at 59.4 metres (195 feet), it is now not even the tallest building in Dublin and it seems its time has come as SIPTU plans to demolish it. In an earlier incarnation it was the headquarters of the ITGWU and of the Irish Citizen Army, and it was from there that the leaders of the 1916 Rising marched to the General Post Office (GPO), complete with a copy of the Proclamation, which had been printed at Liberty Hall. The caption on the postcard is incorrect when it refers to 'storming the Rebel Headquarters' as it was unoccupied during Easter Week 1916 – the damage seen came from shelling by an artillery piece in Tara Street. The Rebel HQ was at the GPO.

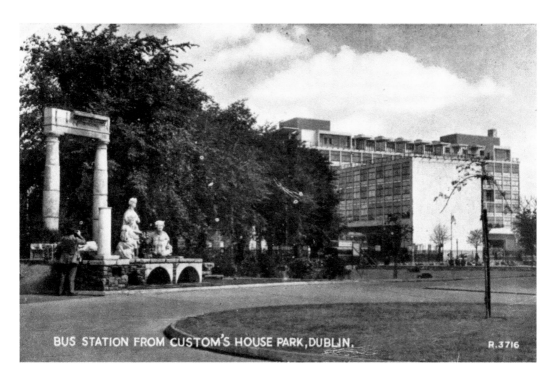

BUS STATION FROM CUSTOM'S HOUSE PARK, DUBLIN.                    R.3716

### Busáras

Officially it is called Árus Mhic Dhiarmada, after the executed 1916 leader Seán Mac Diarmada, but Dubliners just call it Busárus ('the bus building' as Béarla). While Bus Éireann are the most visible tenants, the building is the headquarters of the Department of Social Protection, and the bus company merely rents space. Designed by Michael Scott (he also designed Donnybrook Garage and the Abbey Theatre), it was completed in 1953. From 1959 to 1995, Busárus was home to the Eblana Theatre.

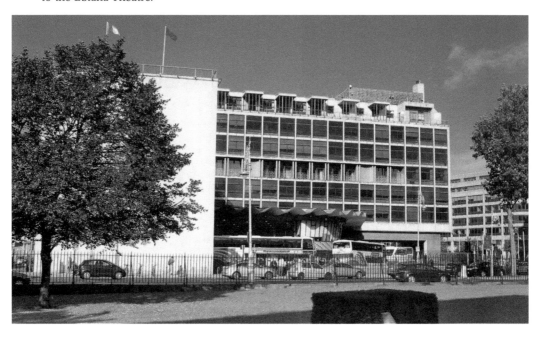

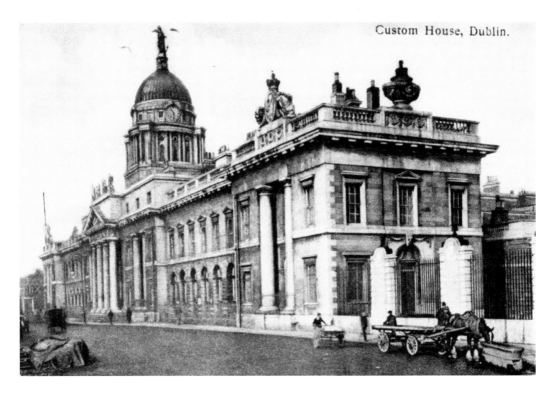

### Custom House

Designed by James Gandon and completed in 1791, it was completely destroyed by a five-day fire in 1921 during the War of Independence – the raid by the Dublin Brigade of the IRA was intended not just to destroy administrative records but as a spectacular act which would be internationally seen as a thrust to the heart of British government in Ireland. Restoration work was completed in 1928 and the building was again restored for its bicentenary in 1991.

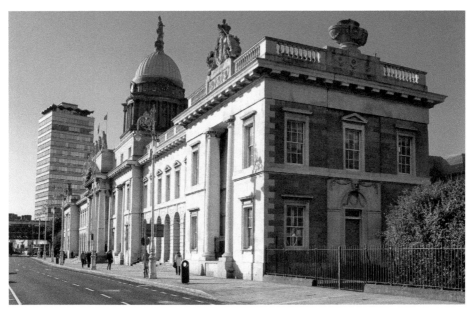

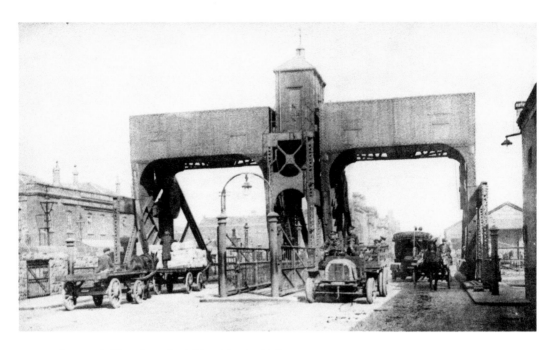

**Scherzer Rolling Bascule Bridge, North Wall**

As ships got bigger in the 1870s there was a pressing need for larger docks in Dublin, particularly on the north side of the Liffey. The Midland Great Western Railway Company, which had taken over the canal in 1845, rose to the challenge and constructed Spencer Dock, providing 3,000 feet of new quays. It was opened on 15 April 1873 and was named after the then-Lord Lieutenant, Earl Spencer (an ancestor of Diana, Princess of Wales). The Scherzer Rolling Bascule Bridge no longer opens.

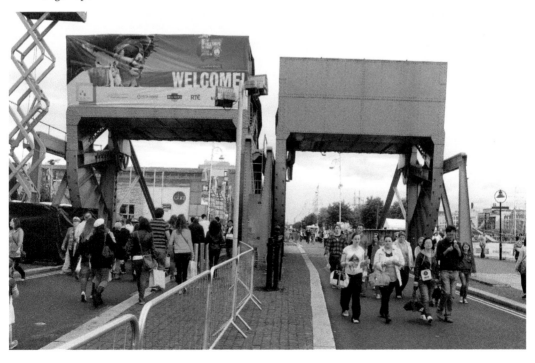

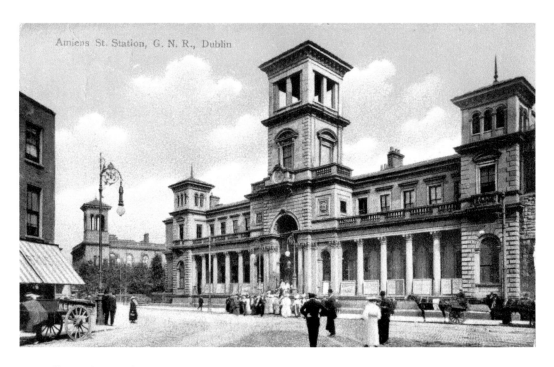

Amiens St. Station, G. N. R., Dublin

### Connolly Station, Amiens Street

The main train station on the north side of the city, it was simply called Dublin station when it was opened in 1844 by the Dublin & Drogheda Railway Company. It was renamed Amiens Street station a decade later, and, finally, Connolly station in 1966. Although the exterior view shown remains remarkably unchanged, the station has been extensively rebuilt and remodelled to provide for the DART and LUAS service.

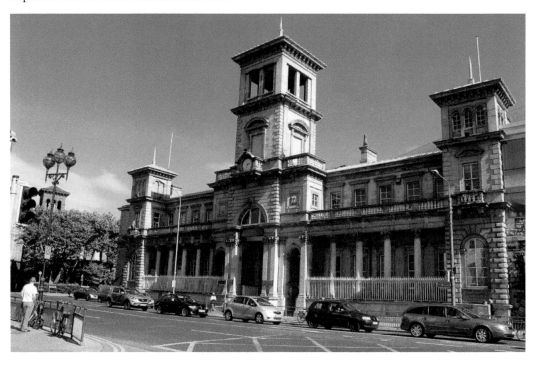

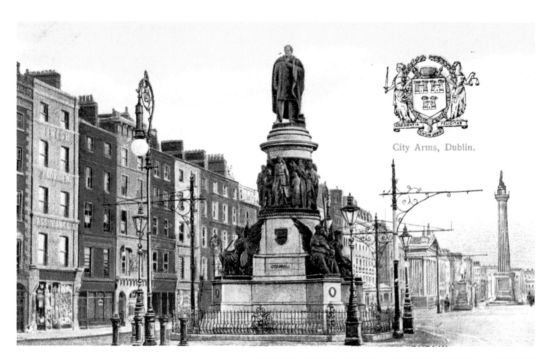

City Arms, Dublin.

## O'Connell Monument

Within months of the death of 'The Liberator' Daniel O'Connell in 1847, there were plans for a monument in Dublin. Money was collected, a committee was formed, but it was to take forty-five years before the scheme came to fruition. The foundation stone was laid in August 1864 but it was a year later before John Henry Foley agreed to create the monument. Through pressure of work and ill health, it was unfinished when Foley died in 1874. It was finally unveiled on 15 August 1882. During restoration work in 2005, around thirty bulletholes dating back to the 1916 Rising were found around the monument – O'Connell was shot twice through the right temple!

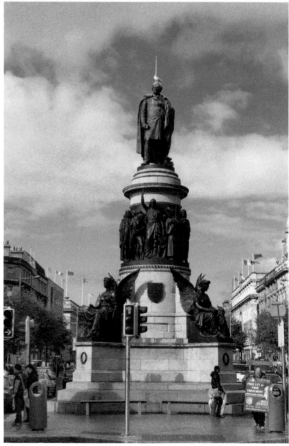

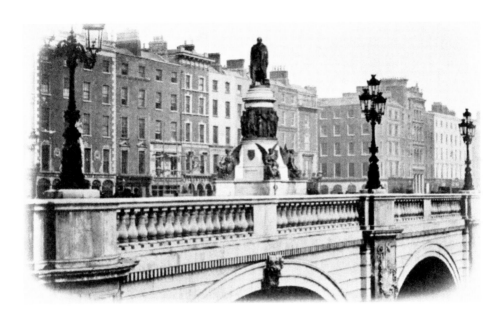

### O'Connell Bridge

Up until 1798 the only way to get from one side of the Liffey at this point in the river was to take a ferry (or a long walk). Carlisle Bridge, named after the then Lord Lieutenant, was narrow and had a hump. It was widened and the hump removed in 1880 – two years later it was renamed after Daniel O'Connell. At 45 metres long and 50 metres wide, it is often claimed to be the only bridge in Europe as wide as it is long.

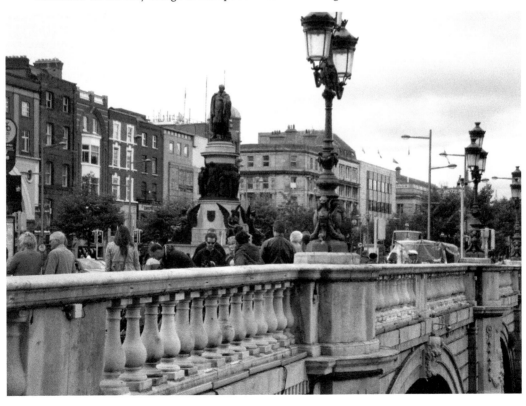

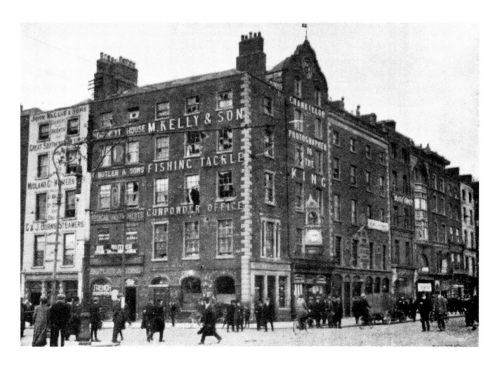

### Kelly's Fort

Corner houses around O'Connell Street were garrisoned on Easter Monday 1916, among them M. Kelly & Son, Fishing Tackle and Gunpowder Office, Bachelor's Walk. As the British cordon tightened around the city centre, 'Kelly's Fort' came under fire from a nine-pounder gun at Trinity College facing D'Olier Street, forcing it be evacuated on Wednesday. Other premises in the older photograph include John Wallis & Sons, Butler & Sons, and Chancellor – Photographer to the King! The shelling from such a short distance was remarkably accurate; there is little damage to the premises on either side of Kelly's.

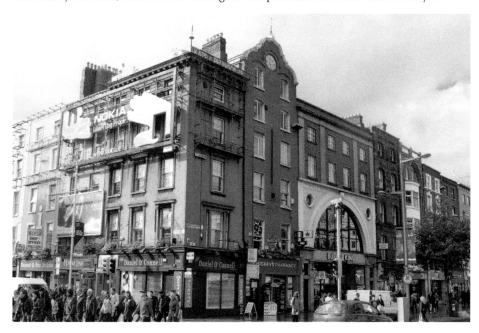

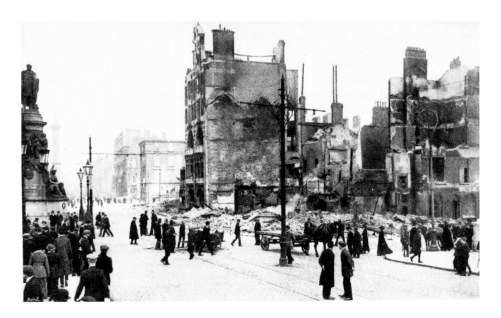

### Dublin Bread Company (DBC), O'Connell Street

The DBC (1901) – the building in the centre of the old photograph – was one of the most noticeable buildings in this stretch of O'Connell Street until it was completely destroyed during 1916. A note sent by James Connolly from the GPO (25 April 1916) to the garrison in the DBC and Reis's read in part, 'Break all glass in the windows of the rooms occupied by you for fighting purposes ... Be sure that the stairways leading immediately to your rooms are well barricaded. The directions from which you are likely to be attacked are from the Customs House or from the far side of the river, Dolier Street or Westmoreland Street.'

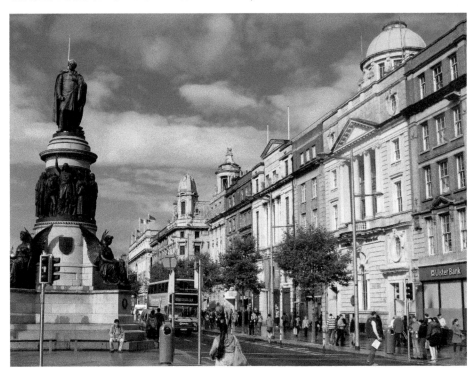

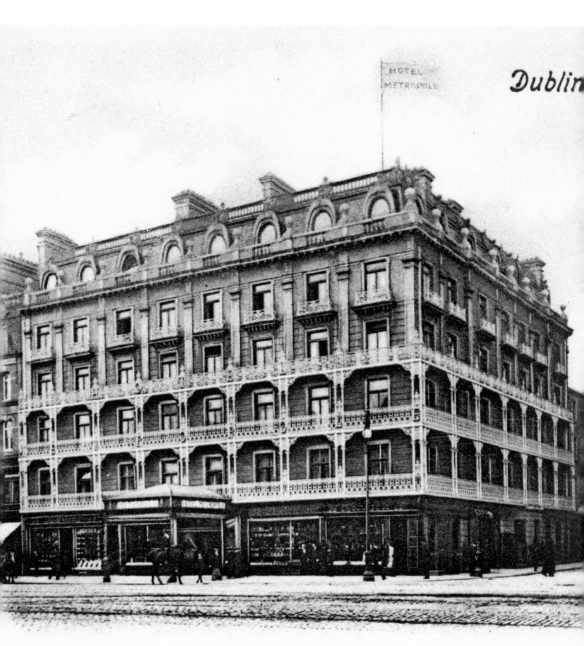

Dublin

Hotel Metropole.

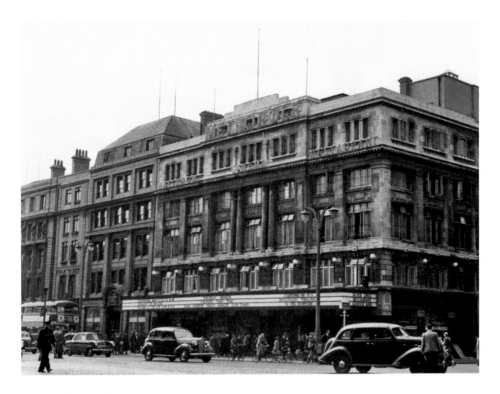

## Metropole Hotel

The 'Met', as it was known, was popular in two incarnations: as a hotel and, later, as a cinema/ballroom. The hotel, which had been operating since the mid-nineteenth century, was destroyed in 1916. It had been originally called 'Spadaccini's' and 'The Prince of Wales'. The Metropole Ballroom, Restaurant and Cinema opened in 1922 and closed on 11 March 1972. The new owners, British Home Stores, demolished it and it is now Penneys.

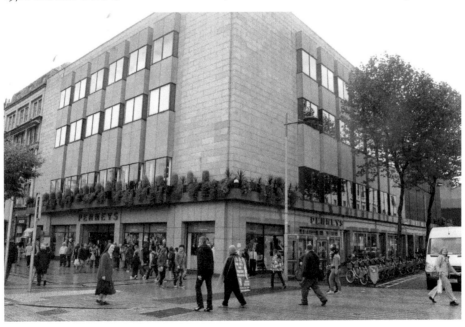

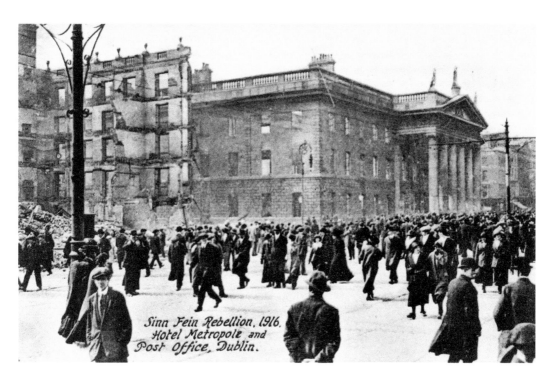

Sinn Fein Rebellion, 1916.
Hotel Metropole and
Post Office, Dublin.

### General Post Office (GPO)

The very centre of Dublin is, for many, that mythical area called 'An Lár', as advertised by Dublin buses. Most, however, would accept that the GPO, opened in 1818, is the centre of Dublin. It's at the heart of the story of 1916 and while it is still a working post office it is also a 'must-see' for Dubliners and tourists alike. Following shelling in 1916, the building was gutted and was not completely restored until 1929.

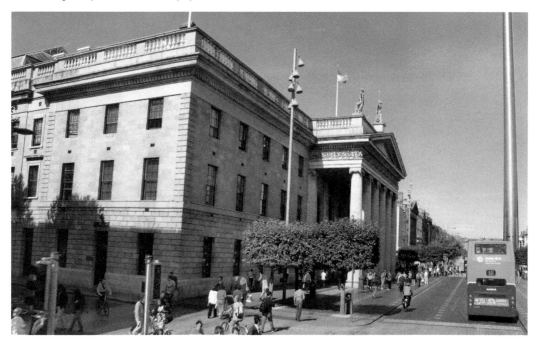

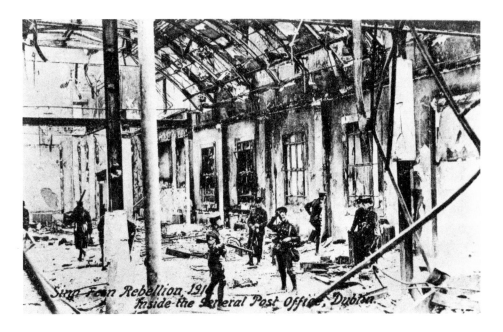

Sinn Féin Rebellion, 1916. Inside the General Post Office, Dublin.

### GPO Interior

By Friday of Easter Week 1916, the GPO was in flames and under continuous shelling from snipers and field guns. The HQ of the Rising was no longer defensible and the leaders made their way to 16 Moore Street, from where the official surrender took place the following morning. Pearse's surrender note read, 'In order to prevent the further slaughter of Dublin citizens, and in the hope of saving the lives of our followers now surrounded and hopelessly outnumbered, the members of the Provisional Government present at headquarters have agreed to an unconditional surrender, and the commandants of the various districts in the City and County will order their commands to lay down arms.'

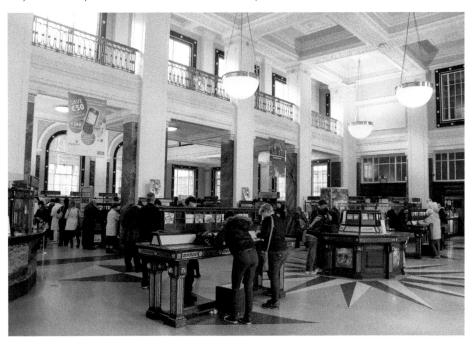

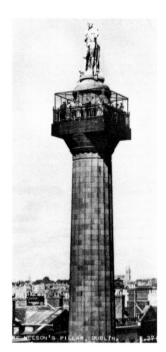

### Nelson's Pillar and the Spire

Nelson's Pillar (1809–1966) may not have been a great work of art but it stood for something. Perhaps it might have survived to this day had the 'one-eyed adulterer' been removed and someone else installed (Brian Boru, St Patrick, the Unknown Gurrier?). The Spire (also known as 'The Monument of Light') was pretty well summed up by author and architectural historian Peter Pearson when he noted, 'The fact that it is a symbol of nothing in particular is perhaps an appropriate monument to our single-minded, economy-driven age.' It's supposed to be self-cleaning, but it isn't (as the Corpo have discovered to their cost).

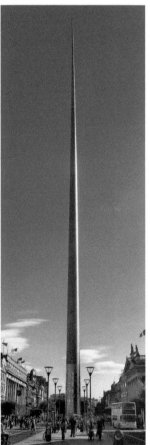

69

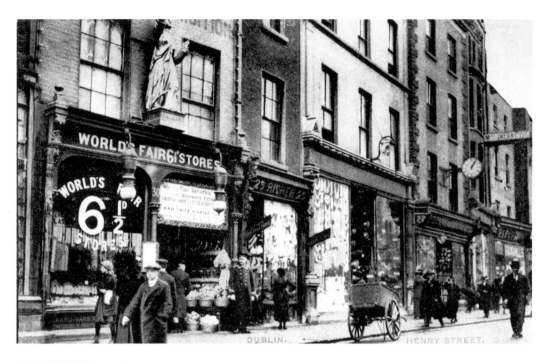

World's Fair, Henry Street

Today it is best remembered by fans of *Ulysses* where James Joyce recalled Marcella the Midget Queen who appeared there from 1893. The shop next door is Richer (No. 29), McDowells' Jewellers was at No. 27 and McInerney's is at No. 26. This entire section of Henry Street was demolished when the GPO was being rebuilt and extended in the 1920s – shop addresses are now GPO rather than Henry Street. Today it is another of those streets where the shops represent little more than depressing globalistic homogeneity.

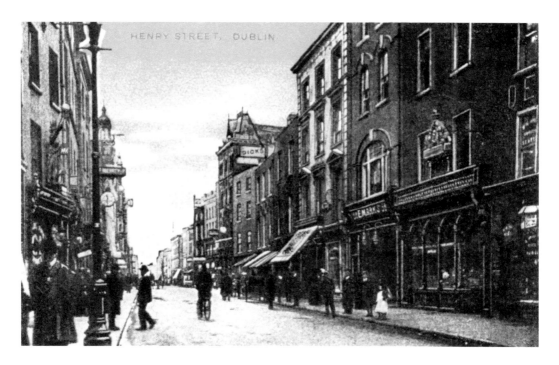

## Mary Street

Many early postcards were hand-coloured – some were almost completely ruined when careless work removed any and all important detail. This postcard is short on detail – and confuses Henry Street with Mary Street – but can be identified as showing the premises of E. Marks, later to become E. Marks & Co. Ltd., Original Penny Bazaar. Michael Marks would probably have completely faded from memory except that he went into partnership with Thomas Spencer. Today Marks & Spencer can be found not too far away, to the left, behind where the modern photograph was taken.

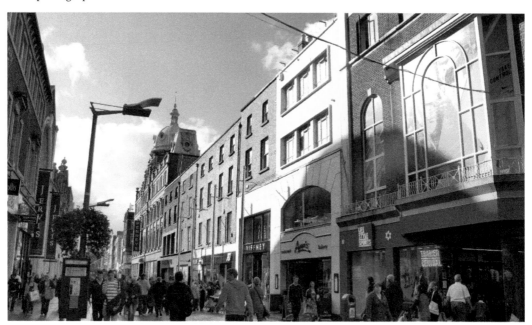

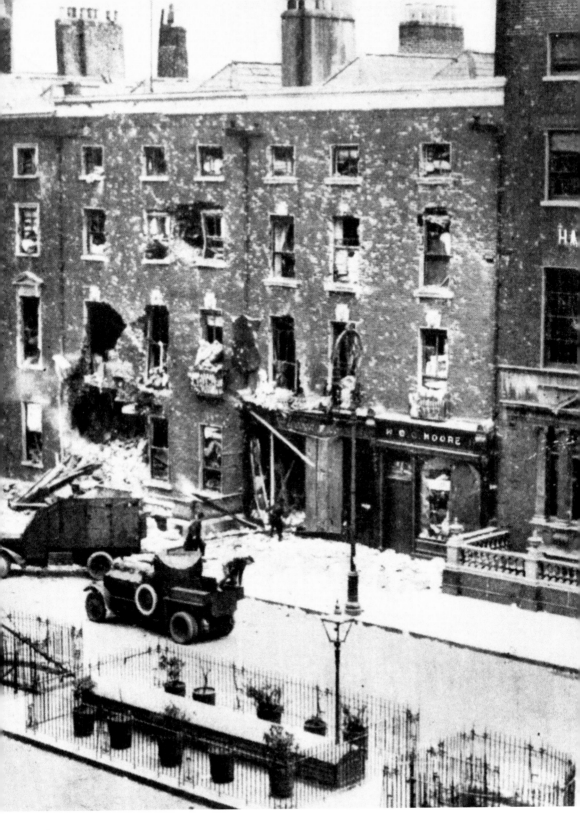

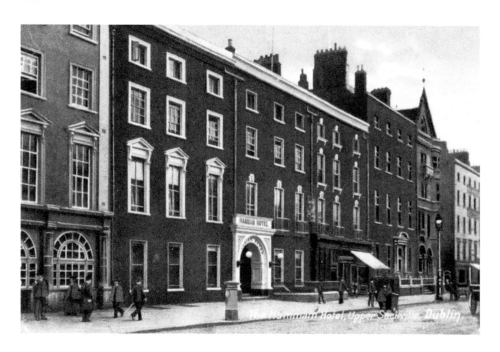

## Hammam Hotel

The full page photograph is described as showing 'Military Operations, Dublin, June–July, 1922, National Troops Bombing Hammam Hotel'. It seems unlikely that this picture was taken during the fighting; a more likely timing is after firing had stopped. At 5 p.m. on 5 July, Cathal Brugha ordered his troops to surrender. Once they were safe he came out of the building carrying a revolver. He was shot in the thigh – in nearby Thomas Lane according to *The Fall of Dublin* by Liz Gillis – and died two days later. The new photograph shows the Hammam Building (centre), and above Burger King can be seen a plaque commemmorating Cathal Brugha.

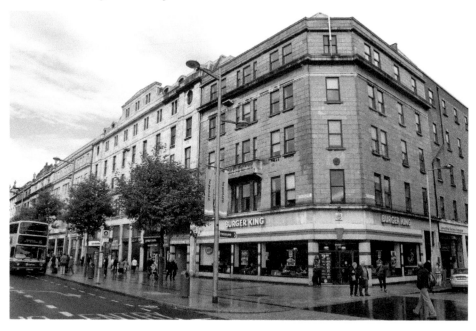

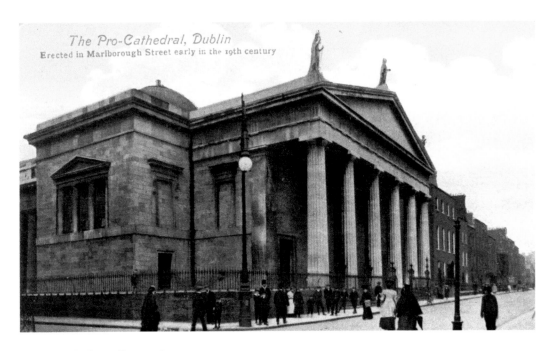

The Pro-Cathedral, Dublin
Erected in Marlborough Street early in the 19th century

Pro-Cathedral, Marlborough Street

Words can be deceptive – there are only two cathedrals in Dublin and St Mary's Pro-Cathedral (1825) is not one of them. It is the acting cathedral until the Roman Catholic Church renounces its longstanding claim to Christ Church or decides to create a new cathedral in the city. There have been various sites put forward for a new cathedral; the one which came closest to fruition was Merrion Square (now a public park), the General Post Office (after the Rising), while the Abercrombie Report (1941) recommended a huge construction fronting onto Lower Ormond Quay.

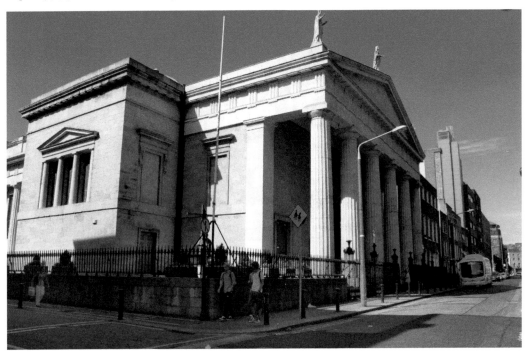

**Pro-Catherdral Interior**
Officially opened in 1825, the first Mass held there was two years earlier for its sponsor, Archbishop Troy. The original altar, shown in the earlier photograph, was sculpted by Peter Turnerelli, and had two angels on either side of the Tabernacle – it was removed, along with the altar rails in the late 1970s. The pulpit has now been removed from its original position and the original Latin inscription is no more. It read, as much as I can make out, '*dicit Jesus Discipulo ecce mater tua*' (Jesus said to the disciple, Behold thy Mother.)

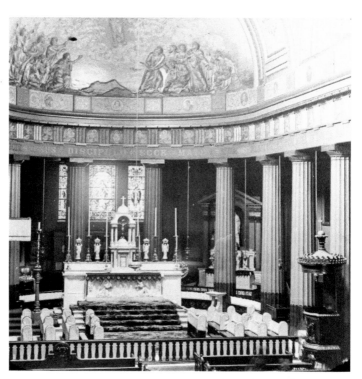

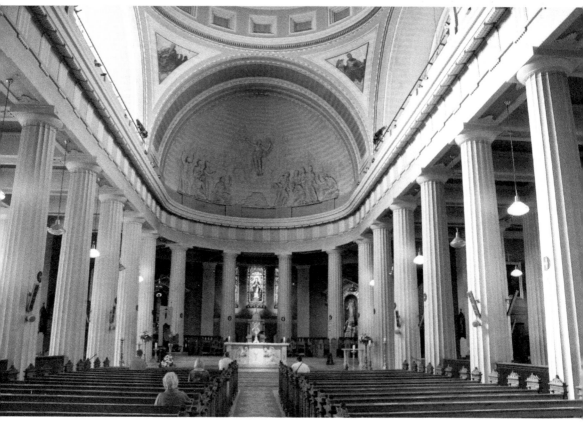

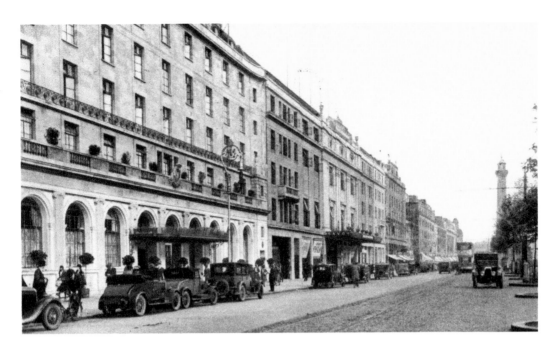

## Gresham Hotel

Hotels come and go but two – the Gresham and Shelbourne – are longstanding landmarks in central Dublin. The Gresham Hotel has been in O'Connell Street since 1817 (the name was officially changed from Sackville Street in 1924, although that change had been on the cards since the 1880s). The building was destroyed during the Civil War in 1922. It reopened in 1927. The Gresham has two happy memories for me – my wedding reception and I once had lunch there with the actor and singer of 'The Dublin Saunter', Noel Purcell.

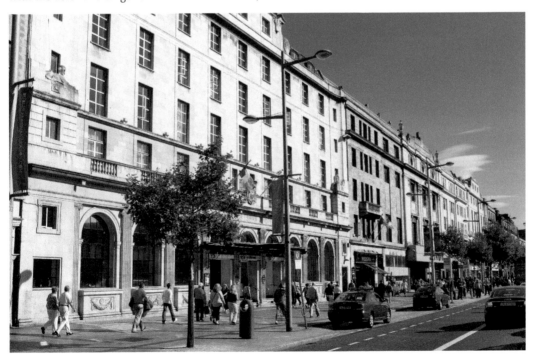

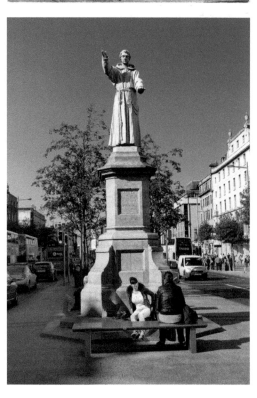

Statue of Father Mathew, Dublin
The great Apostle of Temperance
in the habit of the Capuchin Order

**Father Mathew Statue, O'Connell Street**
Father Theobald Mathew (1790–1856) didn't
believe in half-measures when it came to
drink. His Total Abstinence Society preached
just that: right now, no excuses, never touch
another drop! And it was hugely succesful
– 3 million people by 1845, about half of the
total adult population of Ireland at the time.
Among that number were 70,000 Dubliners
who signed up over just five days. The
foundation stone for his O'Connell Street
statue was laid on 18 October 1890, marking
the centenary of his birth.

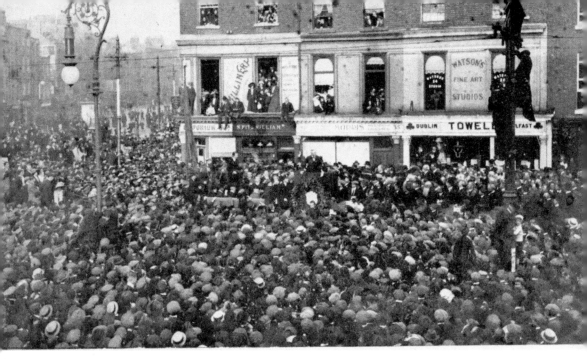

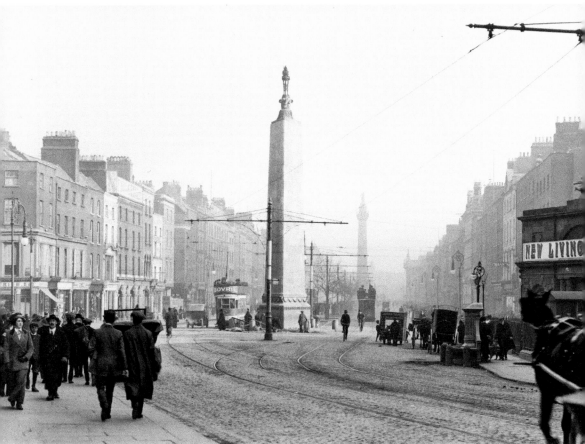

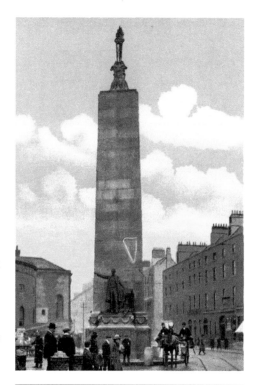

### Parnell Monument

What might have been is always fascinating, never more so than in the case of Charles Stuart Parnell. Just as the 'uncrowned King of Ireland' seemed about to deliver Home Rule for Ireland, he found himself the co-respondent in the 1889/90 divorce of Captain William O'Shea and Mrs Katherine O'Shea. It deeply divided the Irish Parliamentary Party, and scandalised many Catholic supporters. The publicity around the case brought Parnell down and ended any immediate hope of Home Rule. Parnell battled on but died, aged forty-five, on 6 October 1891. The foundation stone of the Parnell Monument was laid on 8 October 1899, but it was not completed until 1911 – the photographs on the opposite page show the unveiling of the monument, on 1 October 1911, by John Redmond MP, and an early view of the back of the monument where work appears to be continuing around the base (this photograph is from the National Library of Ireland on The Commons Photostream, flickr). An inscription reads in part, 'No man has the right to fix the Boundary to the march of a nation' – though as his arm seems to be pointing to the Parnell Mooney pub it is often noted that a good place to plot the route of said march would the very same pub.

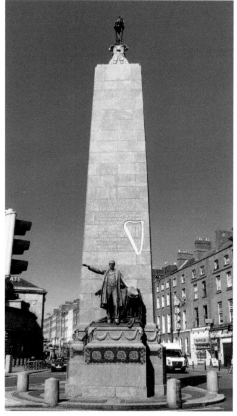

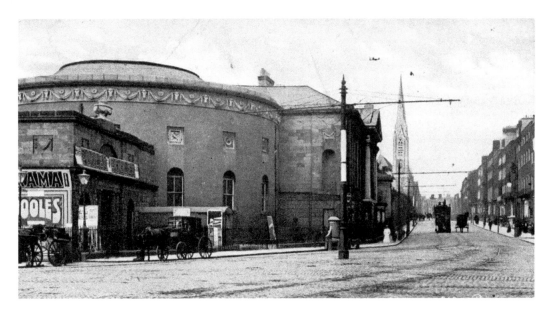

### Ambassador Cinema

It looks kind of old but you would probably be surprised to find out that the Ambassador is, in fact, a remnant of the fundrising efforts by the Rotunda Hospital. It was built in 1764 and worked, in conjunction with the Rotunda Gardens, as part of the ongoing fundraising efforts of the hospital – lectures, recitals, whatever it took to bring the money in. In the early 1900s it became a cinema and, in 1954, was renamed the Ambassador. In recent years it has been a music venue and, most recently, home to the 'Human Body Exhibition'. Plans to turn it into a new central library were dropped in 2011 as it was too small. The Gate Theatre is part of the building and can be seen on the right of the older photograph.

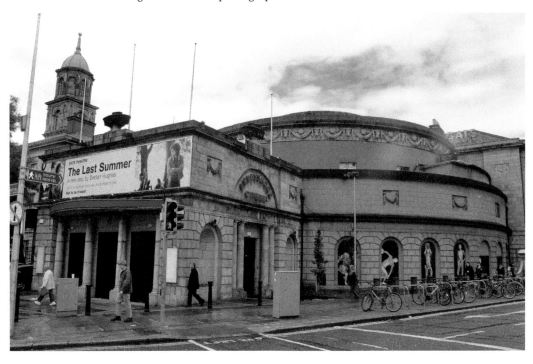

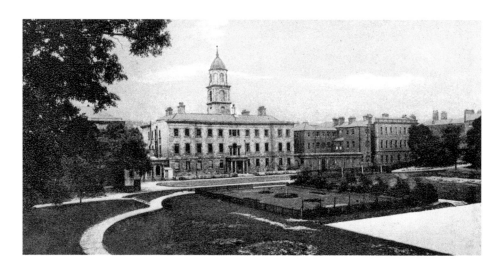

## Rotunda Gardens – Garden of Remembrance

When Dr Bartholomew Mosse opened the Rotunda Hospital (then called the Lying-in Hospital) he had the Rotunda Gardens laid out as pleasure gardens, which he hoped would provide sufficient funding. The *Dublin Penny Journal* noted in 1835 that 'the gardens are open as a promenade on several evenings of the week during the summer season, with the attractions of a band of music and illuminations'. Provision of car parking and extra buildings has greatly diminished the gardens and the major feature of the site is now the Garden of Remembrance, opened in 1966 by President De Valera.

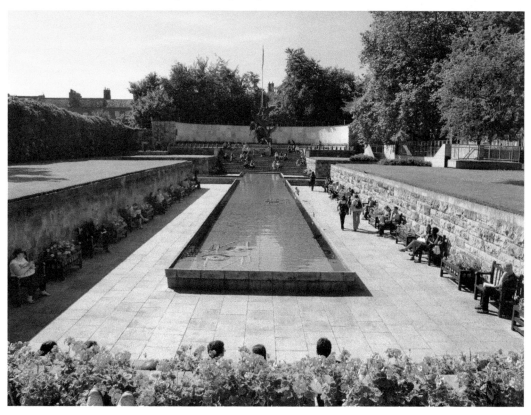

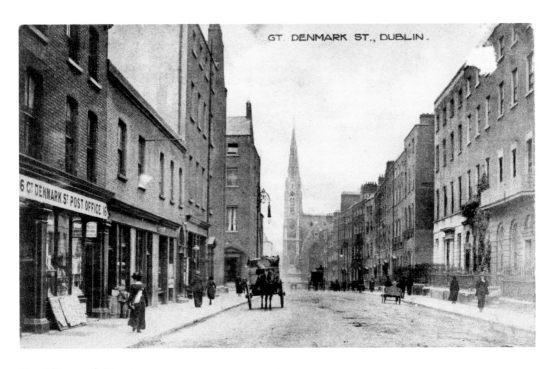

## Great Denmark Street

Originally called Gardiner's Row (1768), the Parnell Square end of Great Denmark Street retained that name when it was renamed in 1792. To the right is Belvedere College, originally Belvedere House (1786), home to the Jesuits since 1841. James Joyce was a pupil, free of charge as his parents were broke, from 1893–98. On the left, what was once the post office is (September 2012) for sale at €225,000 or best offer – not bad for a three-storey over basement two minutes from O'Connell Street.

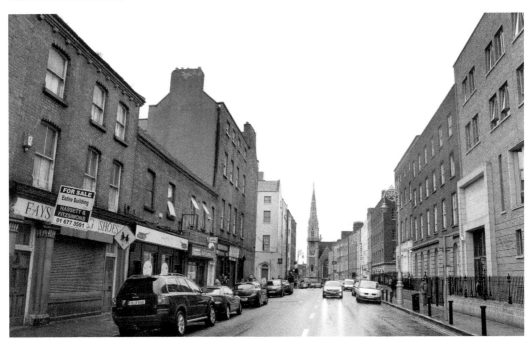

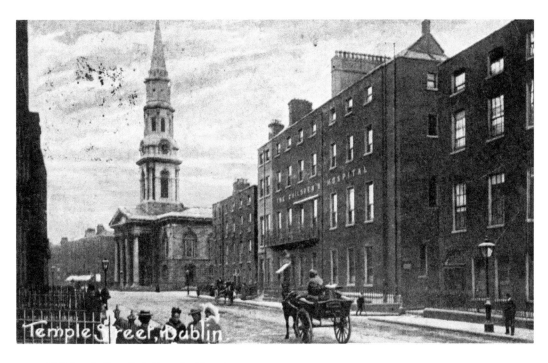

### Children's Hospital, Temple Street

Originally located at 9 Buckingham Street (1872), it moved to 15 Upper Temple Street in 1879 – in the meantime it had been taken over by the Irish Sisters of Charity (1876). In recent years there has been agreement that the children's hospital will relocate to the Mater Hospital when development there is complete – possibly around 2016. The church in the photograph is St George's, Hardwicke Place, which was built in 1802 and de-consecrated in 1991. Parts of the elaborate pulpit can be seen in Thomas Read's pub at the corner of Dame Street and Parliament Street.

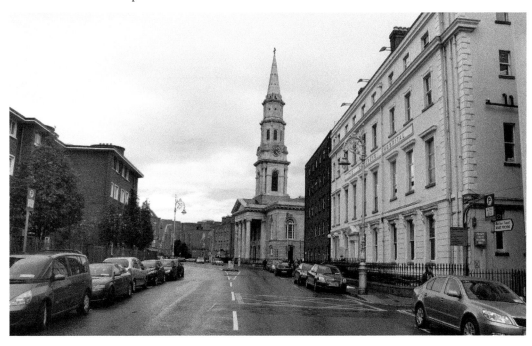

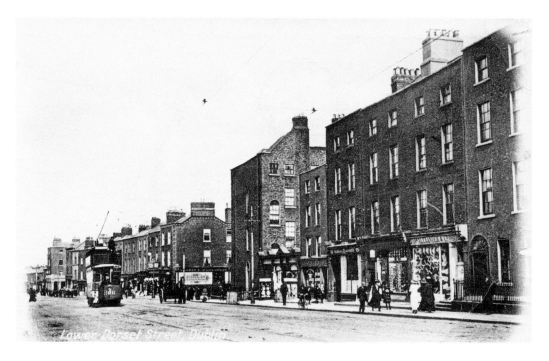

### Dorset Street

Some streets were created as the city expanded, but Dorset Street is a prehistoric route into the city (*Slí Mhidh Luchra*) from the north. Later it was known as Drumcondra Lane and when the Wide Streets Commission (1757–1849) got to work it was laid out much as it is today. In the earlier photograph the building on the right is Alexander & Co., General Drapers, next to it is Harold's Laundry (No. 25), the tram is No. 206 and the pub to the right of it is O'Loughlin's.

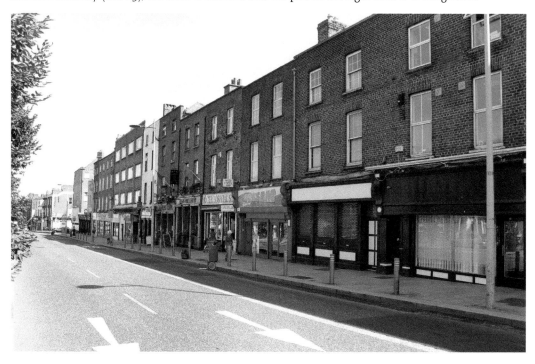

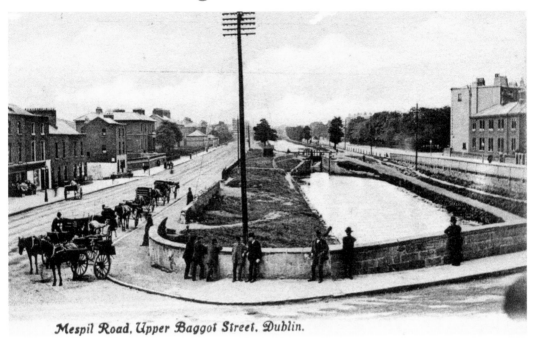

*Mespil Road, Upper Baggot Street, Dublin.*

It's hard to know where exactly you run out of central Dublin, but on the southside at least the Grand Canal is a reasonable choice. On the following pages I have taken a few of the many old Grand Canal postcards and re-photographed them today.

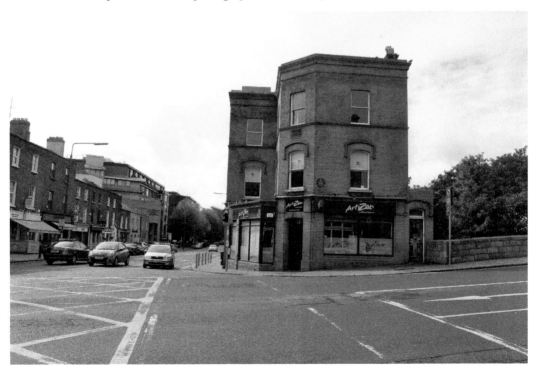

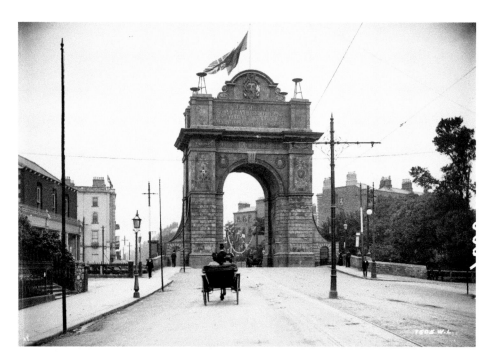

The temporary triumphal arch erected on Leeson Street Bridge for the visit of King Edward VII in 1903. The visit was officially boycotted by Dublin Corporation. *The Times* (London) reported, 'Above the city end of the bridge towered the simulacrum of the ancient city gate, and beyond it was a stand thronged with people. Here the welcome was prodigious ... the roar of cheers from the far side announced the coming of the royal guest some minutes before the head of the procession hove into sight ... the welcome from the stands and the surrounding throng was grand and inspiring; but this time the formal civic welcome ... was most lamentably conspicuous by its absence.'

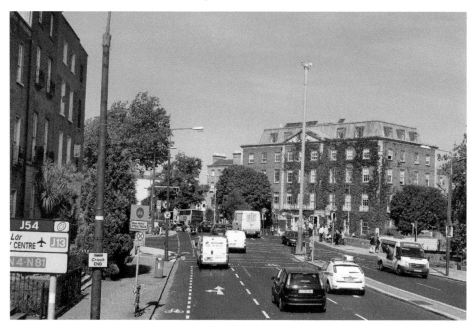

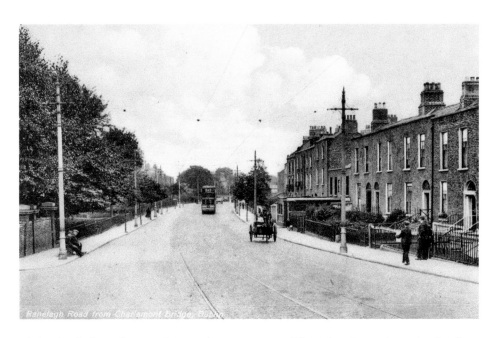

Ranelagh Road from Charlemont Bridge, Dublin

It's hard to believe that canals were the motorways of their day, the vital arteries that kept goods flowing into and out of Dublin. The canals also, though not originally intended to, provided a reliable source of water for the city. The Grand Canal was built over an extended period from 1757 through to 1804, and various sections opened along the way; the route from Sallins to Dublin, for example, was opened in 1780. Linking Dublin with the Shannon (spur lines served towns not close to the route), the volume of yearly traffic was impressive, 200,000 tons by 1810. Speed was not an issue – you could pretty much walk faster – so several hotels were built along the canal, the most notable in Dublin being at Portobello (now Portobello College). Boats left Portobello Harbour (since filled in) for Athy and Tullamore at 7 a.m., and for Shannon Harbour at 2 p.m., arriving at the following day at 11 a.m. and 8 p.m. respectively. In the early years the principal goods carried by over 400 barges were flour, malt, wheat, oats and barley, turf, Kilkenny coal, timber and bricks.

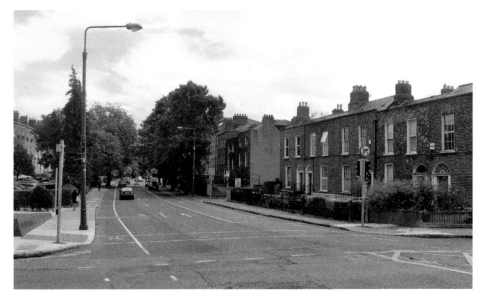

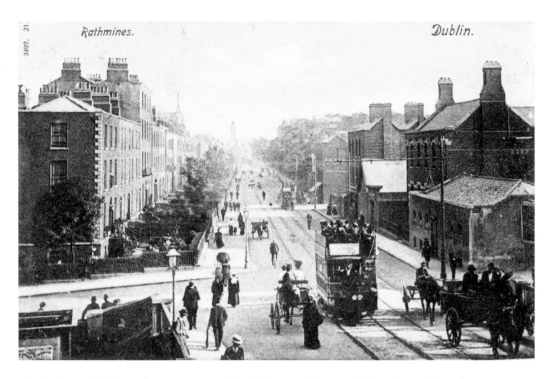

*Rathmines.* *Dublin.*

The heyday of Irish canals came to an end with the introduction of the railways from the 1840s – it was to be a slow decline as it was not until 1960 that the last cargo boat, a Guinness barge, passed through. Since 1999, the Grand Canal has been operated by Irish Waterways.

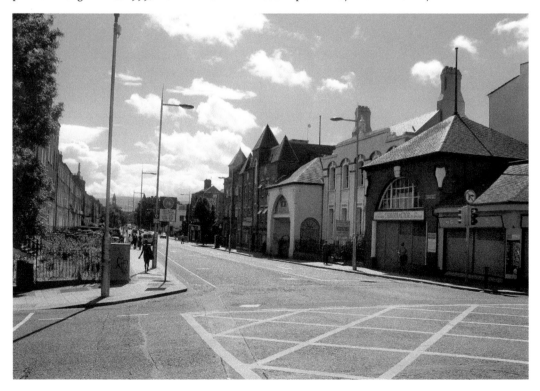

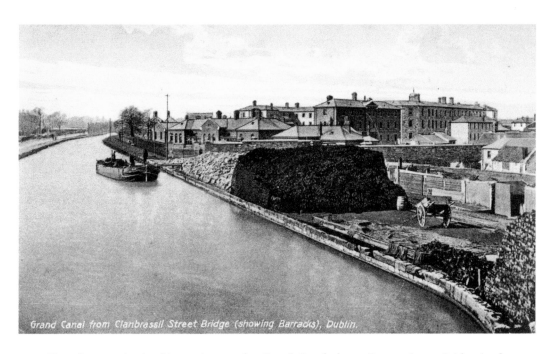

*Grand Canal from Clanbrassil Street Bridge (showing Barracks), Dublin.*

The photographs in this section on the Grand Canal show: Baggot Street Bridge (real name Macartney Bridge, after George Macartney, chairman of the Grand Canal Company); the 1903 Triumphal Arch at Leeson Bridge (real name Eustace Bridge, after the Deputy Chairman of the Grand Canal Co., Lt-Col. Charles Eustace MP); the view towards Ranelagh from Charlemont Bridge (named after the Earl of Charlemont, James Caulfield);the view towards Rathmines from Portobello Bridge (official name La Touche Bridge, after William Digges La Touche, GCC Director); and the view from Clanbrassil Street or Harold's Cross Bridge (officially Robert Emmet Bridge since 1936) showing fuel suppliers in both old and new photographs.

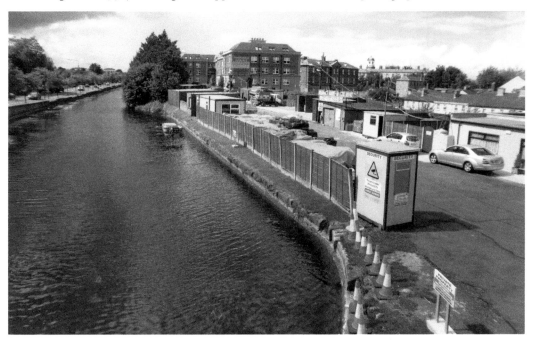

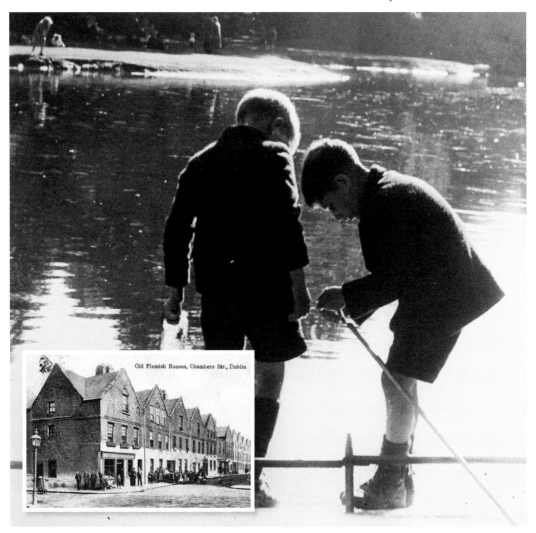

Old Flemish Houses, Chambers Str., Dublin

The following pages show some images that could not be reproduced, and others which I took while working on this book.

'Got Him', by A. Hutchinson: I bought a collection of glass slides fifteen to twenty years ago, some by A. Hutchinson – I never did find out who he was, though he was an excellent photographer. Among the photographs was this one of two youngsters fishing for 'pinkeens' in St Stephen's Green. I, too, was a 'pinkeen' hunter there in my youth, though the pastime seems to have dropped from favour these days. There was not much point in recreating it ... but it is too nice an image not to be used.

Chamber Street: Pictured in the inset, from the junction with Weaver's Square. All of the houses in this postcard have long since disappeared and the area shown is now flattened and fenced off. The houses were known as 'Dutch Billies' and from the mid-1600s to the mid-1800s they formed a goodly proportion of the housing stock. Most were demolished, some were remodelled as Georgian buildings and there are now no original examples in the city. There are some modern replicas which can be found on Kevin Street and Leeson Street. The shop in the photograph is No. 25 and seems to read J. Caffrey.

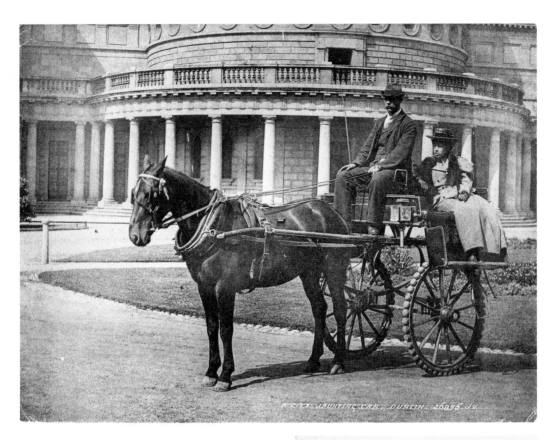

*Above – Jaunting Car*: You can still get a jaunting car in Killarney, but they have vanished from the streets of Dublin (more modern carriages can still be found for hire). The two-wheeled jaunting car was drawn by a single horse and seated up to four people back to back, facing the streetscape rather than the street ahead. Foot-boards projecting over the wheels protected passengers' legs. This old photograph was taken in the grounds of Leinster House, with the National Library in the background.

*Right – Round Tower, Dame Street*: Erected to mark the 1932 Eucharistic Congress, this Round Tower was a temporary structure on Dame Street – the other major city-centre change, outside of the decorations which were everywhere, was a large altar in the middle of O'Connell Bridge on the Ha'penny Bridge side. The Round Tower, which looked better from a distance as the stonework and windows were simply painted on, was removed shortly after the Eucharistic Congress ended.

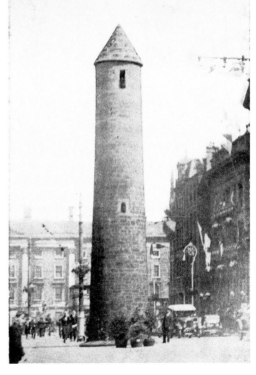

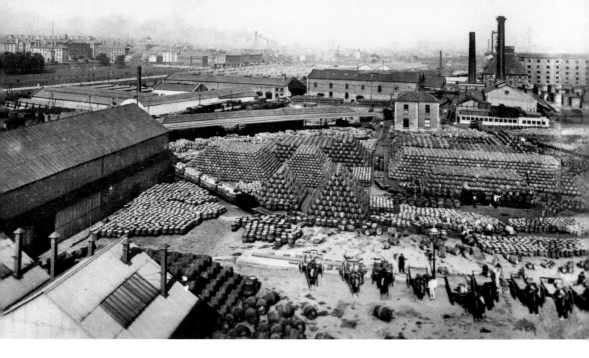

*Guinness Brewery*: In days of yore, Guinness was one of the biggest employers in the city, and while the company boasted that it never ran a advertisement in a national newspaper until 1929 that didn't mean it didn't advertise itself. There were many postcards, an official tourist guide to the brewery and, of course, a constant stream of Guinness barges and carts to and from James' Street. Today the Guinness story can be experienced in the Guinness Storehouse, the top tourist attraction in the city.

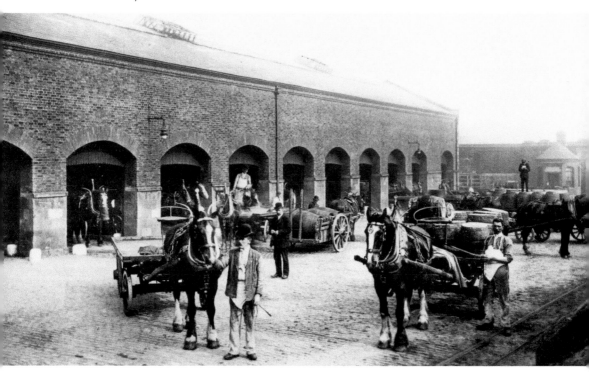

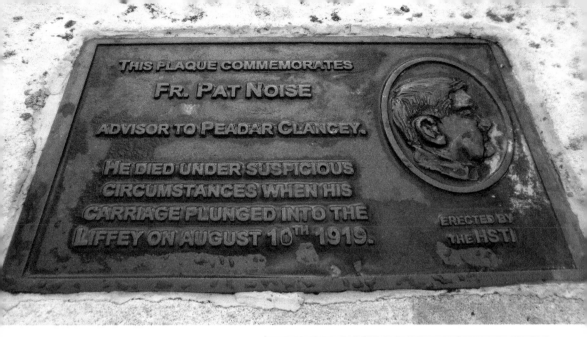

THIS PLAQUE COMMEMORATES
FR. PAT NOISE
ADVISOR TO PEADAR CLANCEY.

HE DIED UNDER SUSPICIOUS
CIRCUMSTANCES WHEN HIS
CARRIAGE PLUNGED INTO THE
LIFFEY ON AUGUST 10TH 1919.

ERECTED BY THE HSTI

*Above – Plaque*: When the ill-fated Millennium clock (the 'Chime in the Slime') was finally and ignominiously removed, a depression which had contained a control box was left on the parapet of O'Connell Bridge. Some kind souls filled it in with a plaque to the memory of the fictitious Father Pat Noise. There was the usual hubbub about vandalism, but (having been removed once) it remains there to this day. It cheers me up everytime I walk by.

*Right – Newspaper Selling*: Youths, sometimes children, were still selling newspapers on the streets of Dublin in the 1960s – their familiar chant of 'Herryorpress' (*Herald* or *Press*) still rings in my memory. Today they have been replaced by adults who never seem to say a word. The photograph is, however, deceptive; the urchin pictured is dressed up (or down!) for the photograph, and his parents would have had a conniption if he had chosen that career path.

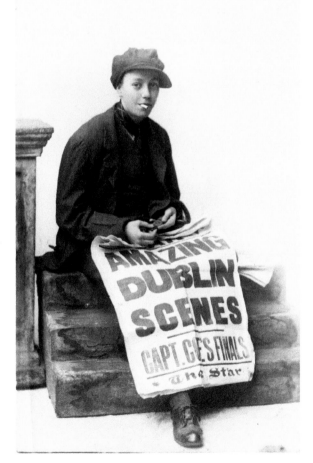

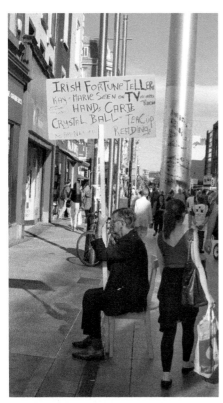

*Left – Fortune Teller*: Spend some time looking at old photographs of Dublin and you'll notice men and boys, never women, carrying boards and placards advertising various wares. They are still around, though the Dublin Traffic Bye-Laws, 1937, seems to have banned them completely: 'No person on foot shall, in any street within the Dublin Metropolitan Area (*shall*) carry, by way of advertisement, any picture, print, board, placard, or notice on any footway.' That certainly told them!

*Below – Huguenot Cemetery*: It is one of life's small mysteries that this tiny cemetery has survived since it opened in 1693 (the last burial there was in 1901). It's not open to the public, but can be clearly seen through the railings. The Huguenots came to Ireland from France after religious persecution in the seventeenth century. Small in numbers they punched above their weight and many of their names are still familiar to Dublin history buffs – for example, Le Fanu, D'Olier, L Touche. In it can be found the DuBédat family plot. The most famous member being Francis (Frank) DuBédat, who was President of the Dublin Stock Exchange before being revealed as a fraudster and thief in 1890.

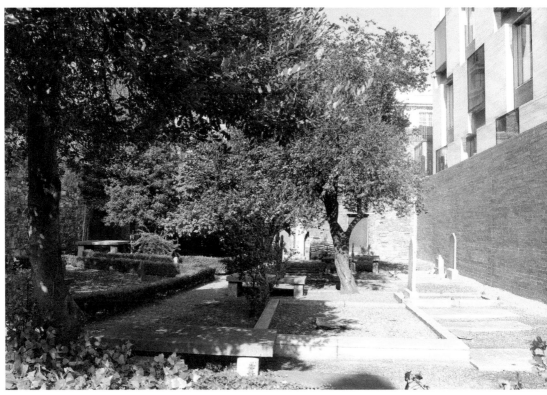

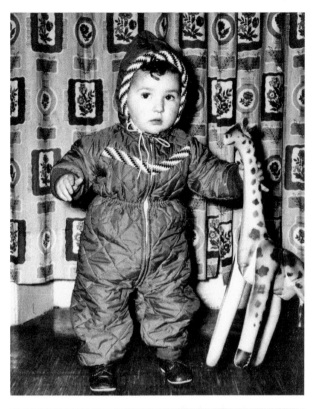

Ken Finlay; Then & Now
Back in the 1960s romper suits were all the rage, particularly if you got regular clothing parcels from relatives in the USA – whatever arrived was what you were dressed in until it wore out or was passed on to the next child in line. These days I get to pick my own clothing, usually a variant of what you see in the modern photograph.

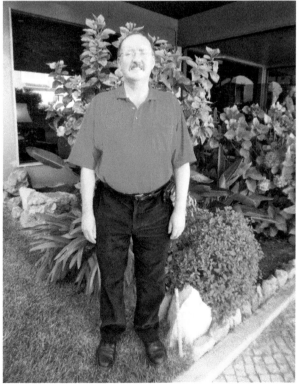

# Acknowledgements

This book would not have been possible without the help of my friend and colleague in the Old Dublin Society, Tony Behan. He very kindly gave me free access to his postcard collection, and even let me take a bundle home – which, as every collector knows, goes against every rule in the book.

My wife, Anne, patiently allowed postcards and books to dominate our home for the past couple of months – I promise it will all be cleared away soon.

Livinus Killeen and Barry Farrell put a lot of their time and energy into proofreading – any errors you find are entirely my fault.

Many people were very helpful as I walked the streets of Dublin - the staff of the Jewish Museum, Portobello, the National Concert Hall, Earlsfort Terrace, and of the National History Museum, Kildare Street, in particular.

Some photographs were taken from the National Library of Ireland's collection on The Commons' photostream (flickr) - it's a great site to visit, I highly recommend it.

All the modern photographs were taken by me, and some of the original postcards are from my own modest collection. I purposely did not give much information on each individual postcard as it would have taken up too much space, but if you have a question just email me – kenfinlay@gmail.com

Finally, if you have an interest in the history of Dublin, you will always be welcome in Old Dublin Society. There are free public lectures held throughout the year in the Dublin City Library and Archive on Pearse Street (former the Gilbert Library), and members receive two issues a year of *The Dublin Historical Record*. Full details can be found at www.olddublinsociety.ie